The Best of
WATERCOLOR 2

selected by Betty Lou Schlemm and Larry Webster

First published in the United States of America by:
Quarry Books, an imprint of
Rockport Publishers, Inc.
33 Commercial Street
Gloucester, MA 01930-5089
Telephone: (508) 282-9590

Distributed to the book trade and art trade in the United States by:
North Light Books, an imprint of
F & W Publications
1507 Dana Avenue
Cincinnati, Ohio 45207
Telephone: (800) 289-0963

Other Distribution by:
Rockport Publishers, Inc.
Rockport, Massachusetts 01966-1299

ISBN 1-56496-251-2

10 9 8 7 6 5 4 3 2 1

Designer: Lynn Pulsifer
Front cover image: Page 79
Back cover images: (clockwise from top left): Pages 138, 115, 124, 7

Printed in Hong Kong by Regent Publishing Services Limited

The Best of
WATERCOLOR₂

selected by Betty Lou Schlemm and Larry Webster

QUARRY BOOKS
GLOUCESTER, MASSACHUSETTS
DISTRIBUTED BY NORTH LIGHT BOOKS,
CINCINNATI, OHIO

Get Ready to
DISCOVER

There are exciting discoveries to be made within the pages of this book, ones that will acquaint you with the unlimited range of creative uses of watercolor and introduce you to artists who are exploring those possibilities. As you turn the pages, you'll find new ways of handling the medium, fresh ideas for interpreting subject matter, original styles of expression, and personal explorations of the visual world. At times you may feel daunted by the technical possibilities available to you, and you may even feel challenged by the number of talented artists using watercolor, but as you absorb the information and integrate it into your own creative enterprise, your painting should continue to get better and better.

I've been writing and editing articles about watercolor for nearly twenty years, and I'm always amazed at the discoveries being made by artists who use four rather simple materials: paper, brushes, paint, and water. I suppose that's because those four ingredients are so sensitive to individual manipulation. A change from rough to hot pressed paper, or a shift from a staining to a non-staining color will have a significant impact on the painting that results. Add to that the variations in amounts of water, brush design, sequence of color application, humidity, and angle of the work surface, and those simple materials suddenly afford artists dozens of creative possibilities. And if you expand the discussion from transparent watercolor to acrylics, gouache, egg tempera, water-soluble pencils, and other materials that are commonly used by watercolor artists, then the number of possibilities grows exponentially.

How do you choose from among all these materials, techniques, styles, and subjects? The only reliable guide through the maze of alternatives is to follow your heart. When something feels right, when it gets you excited, or when it leaves you feeling satisfied, then it is a viable direction for your work. As you turn the pages of this book take note of the paintings that stimulate those kinds of responses and try to determine how the artist achieved the effect you find so captivating. Did they find a provocative subject or present a more traditional image? Have they used the paints in a special way or followed standard procedures? Is the composition balanced symmetrically or asymmetrically? Has the artist brought your attention to the center of interest with directional lines or value arrangements? Is the palette of colors limited or expansive? The answers to those kinds of questions will help you determine your own course of action.

If you keep this book close to your painting supplies, I'm sure you'll be flipping back through it to refresh your memory of paintings you've admired and to consider new approaches. The process of discovery will continue for as long as the binding on the book holds the pages together!

M. STEPHEN DOHERTY
Editor-in-Chief
American Artist

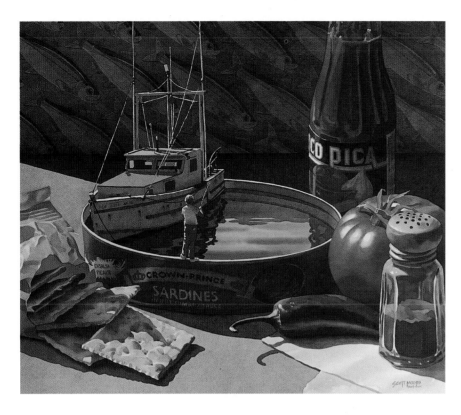

SCOTT MOORE
Fish in a Can
24" x 28" (61 cm x 71 cm)
Arches 140 lb. cold press

NORIKO HASEGAWA
Bizen Teabowl
18" x 24" (46 cm x 61 cm)
Waterford 300 lb. cold press

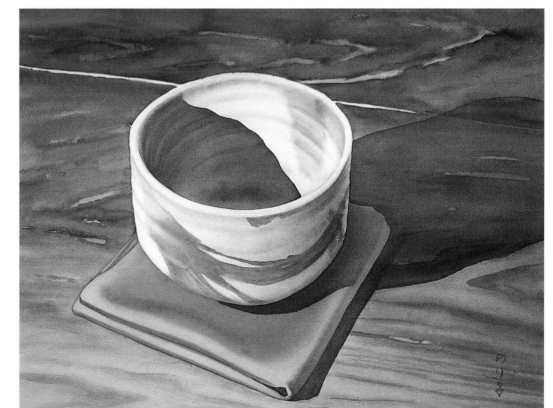

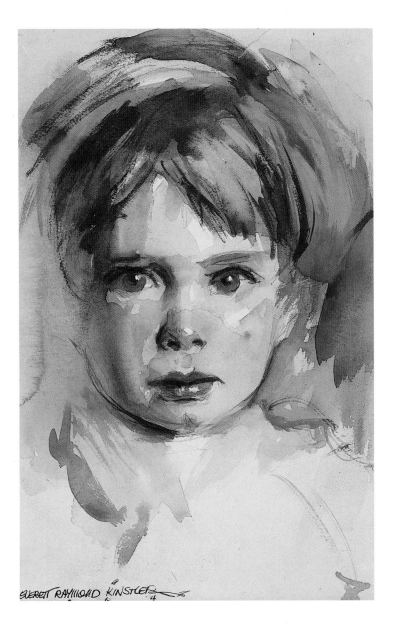

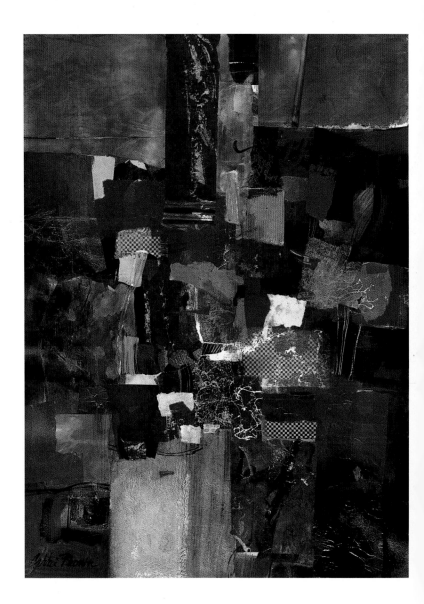

EVERETT RAYMOND KINSTLER

Dana

8" x 10" (20 cm x 25 cm)

Arches hot press

Watercolor and gouache

CARRIE BURNS BROWN

Jubilee

30" x 22" (76 cm x 56 cm)

Arches cold press

Watercolor inks acrylic and collage

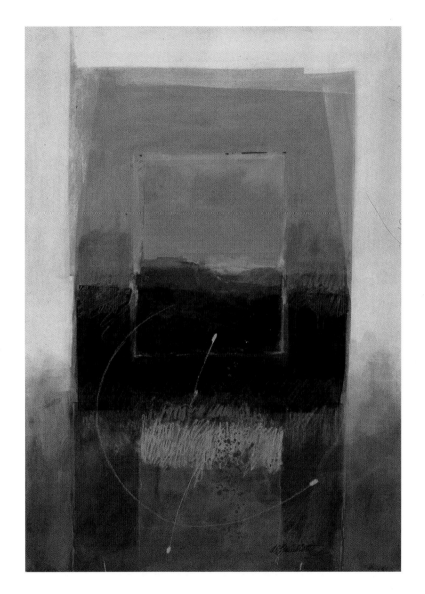

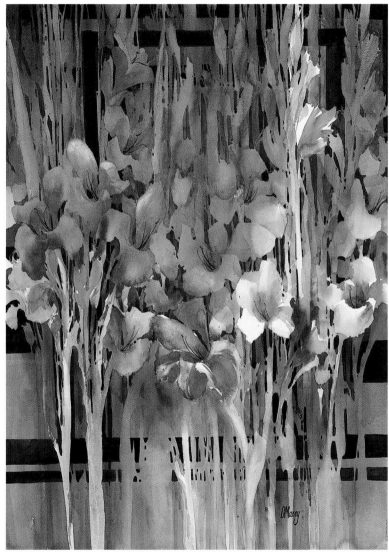

AL BROUILLETTE
Passages II
27" x 19.5" (69 cm x 50 cm)
Fabriano Classico 140 lb.
Watercolor, acrylic color pencils,
and Caran D'Ache crayons

DIANE MAXEY
Intertwined
30" x 22" (76 cm x 56 cm)
Arches 140 lb. cold press

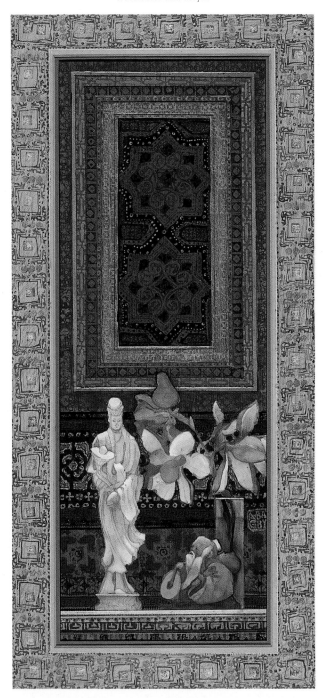

ANNE BAGBY
Old Man and the Goddess
40" x 10" (102 cm x 25cm)
Arches 140 lb. cold press
Watercolor and acrylic

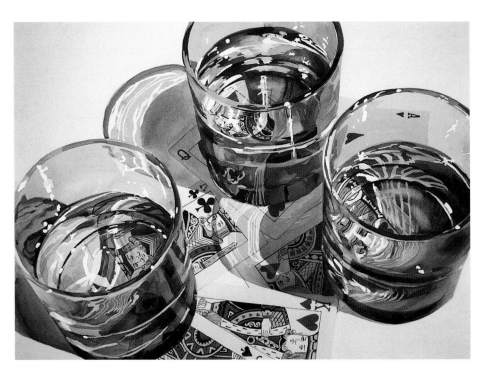

SUZANNE McWHINNIE
Playing Cards and Glasses
22" x 30" (56 cm x 76 cm)
Arches 140 lb. hot press

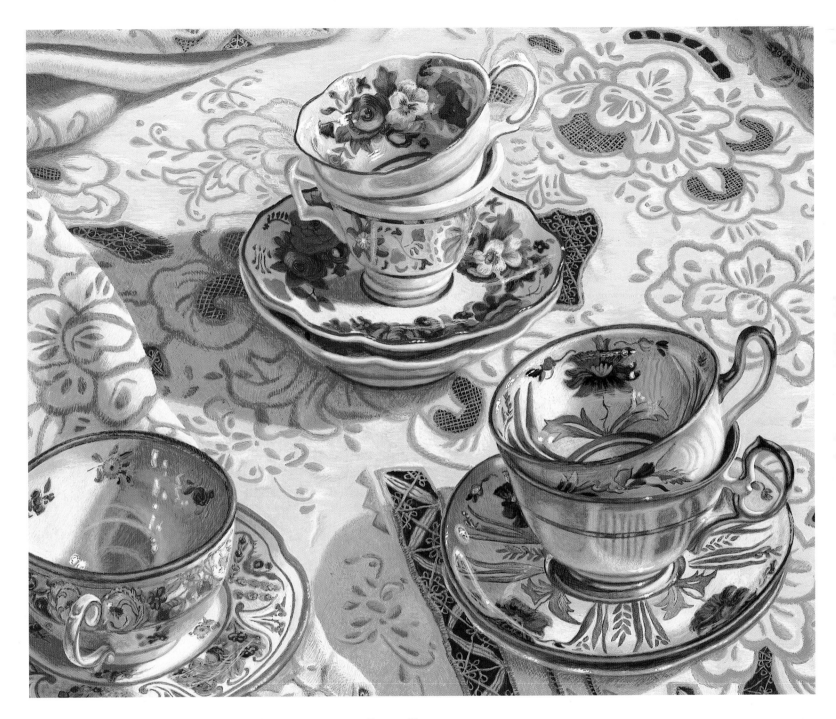

JANIS THEODORE

Five Floral Teacups

10" x 12" (25 cm x 30 cm)

Strathmore museum board

Watercolor and gouache

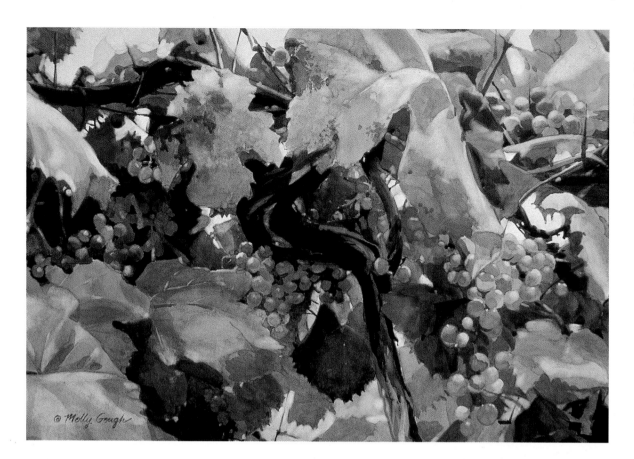

MOLLY GOUGH
Generations
12" x 18" (30 cm x 46 cm)
Strathmore 4-ply bristol
Watercolor and gouache

JANICE ULM SAYLES
The Glass Hat
19" x 29" (48 cm x 74 cm)
Arches 140 lb. cold press

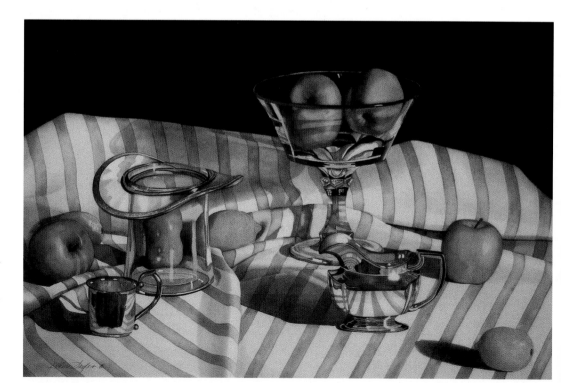

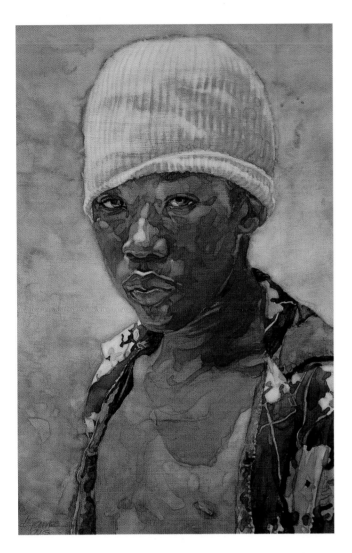

BILL JAMES
Stocking Cap
17" x 11" (43 cm x 28 cm)
Crescent
Watercolor and gouache

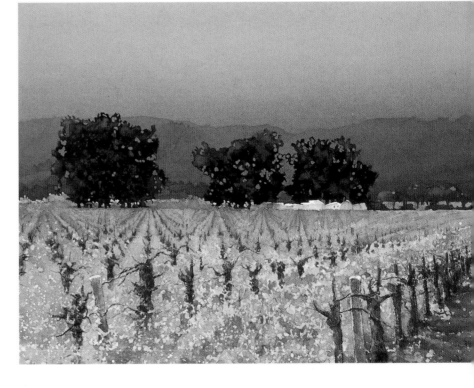

CATHERINE ANDERSON
Fields of Gold
22" x 30" (56 cm x 76 cm)
300 lb. hot press

11

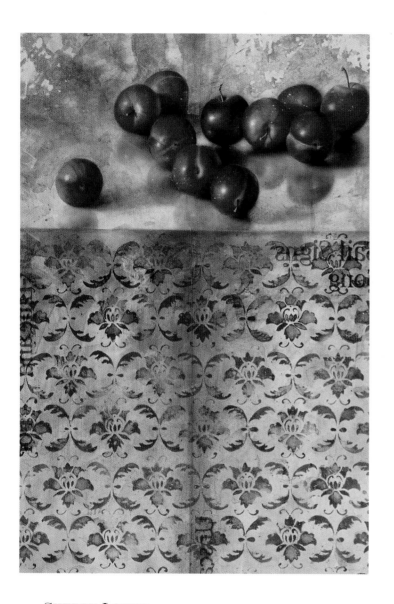

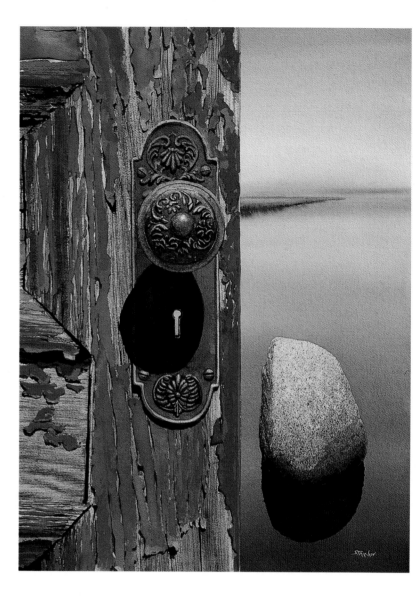

SHERRY LOEHR
Black Plum
26" x 20" (66 cm x 51 cm)
Arches 140 lb. hot press
Watercolor and acrylic

GREGORY STRACHOV
Afterthought
24" x 18" (61 cm x 46 cm)
Arches 140 lb. cold press

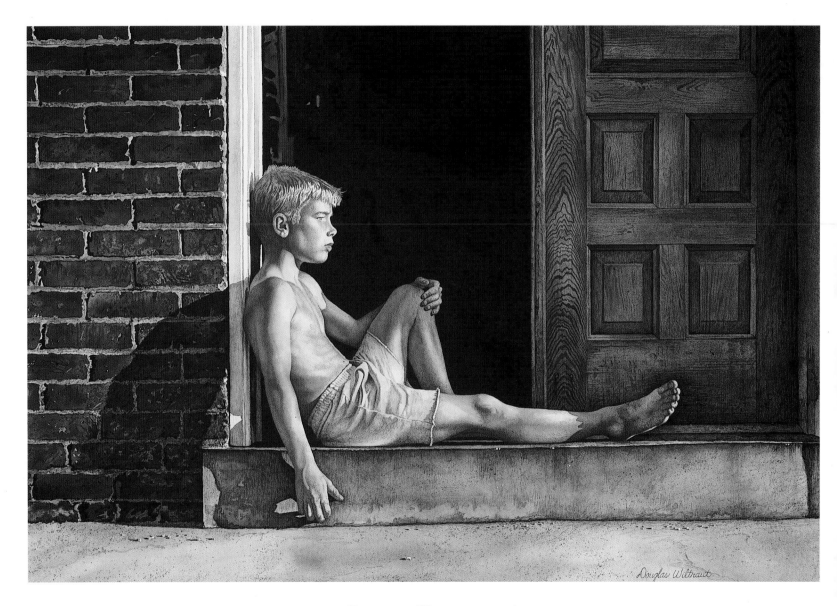

DOUGLAS WILTRAUT

Setting Son

26.5" x 39" (67 cm x 99 cm)

Arches Double Elephant 300 lb.

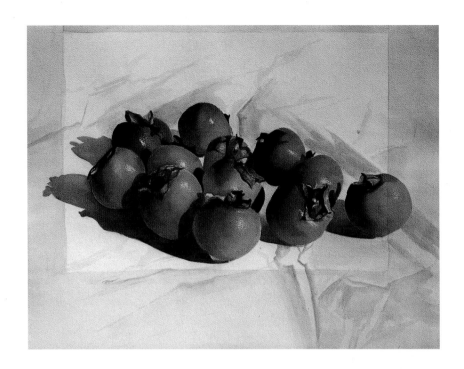

JUDITH KLAUSENSTOCK
A Dozen Persimmons
18" x 25" (46 cm x 64 cm)
Arches 140 lb. cold press

KATHERINE CHANG LIU
Token II
18" x 20" (46 cm x 51 cm)
Lanaquarelle 300 lb. cold press
Watercolor, gouache, acrylic, and collage

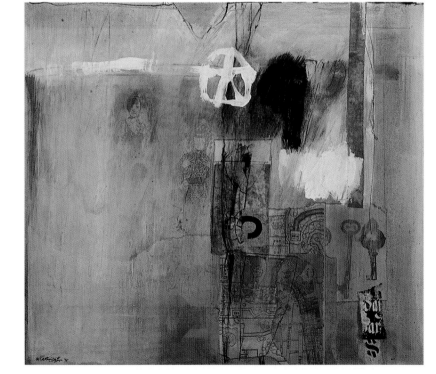

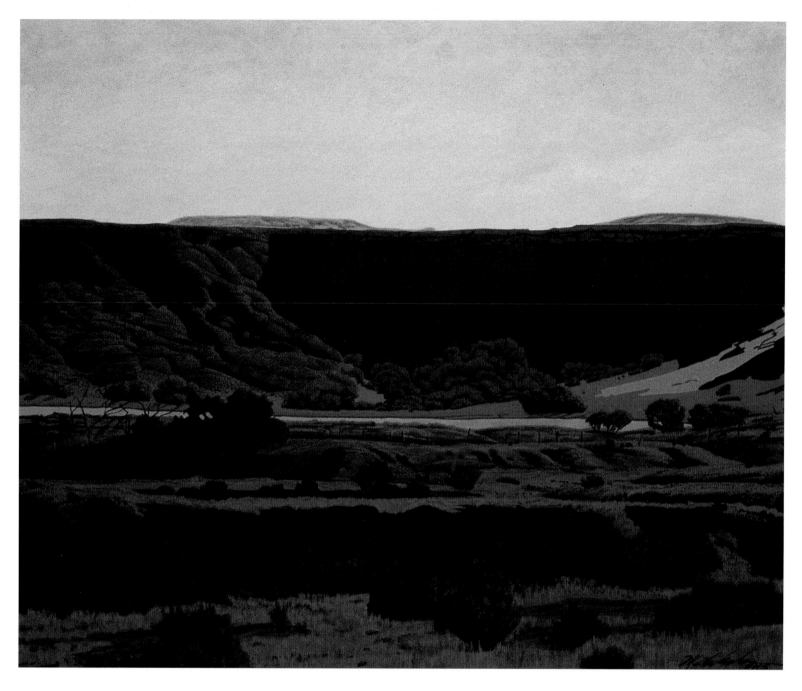

MICHAEL L. NICHOLSON

Selenite Sunrise

14" x 17" (36 cm x 43 cm)

2-ply bristol with gesso

Watercolor, acrylic, and graphite

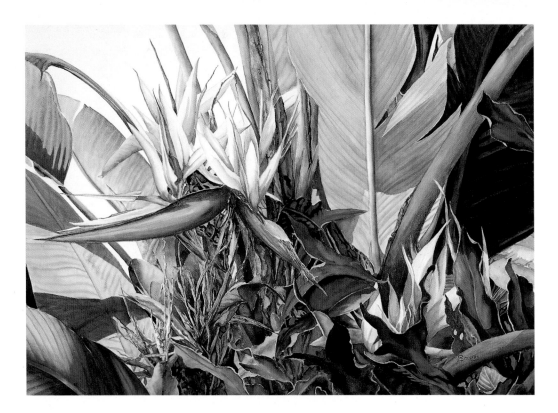

JUNE Y. BOWERS
Bird of Paradise
29.5" x 41" (75 cm x 104 cm)
Arches 555 lb. cold press

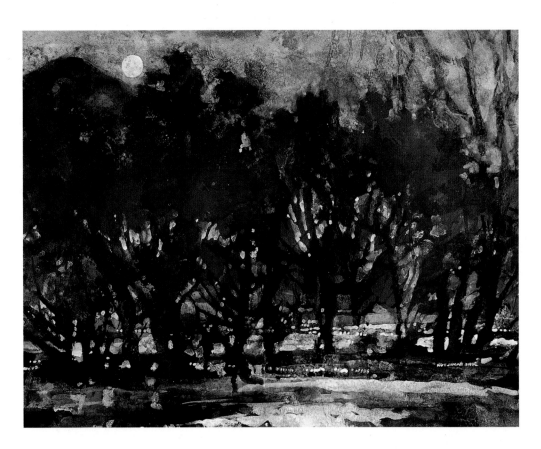

DODIE HAMILTON
October Moon
22" x 28" (56 cm x 71 cm)
Morilla
Watercolor, acrylic, and gouache
Special Technique: Used plastic
wrap and applied pressure
while printing.

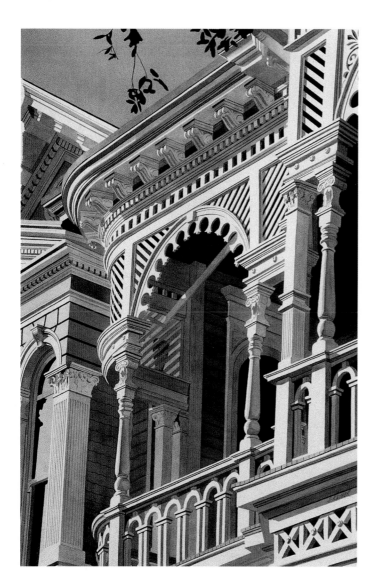

L. Herb Rather, Jr.
Victorian Galveston
30" x 22" (76 cm x 56 cm)
Arches 140 lb. rough

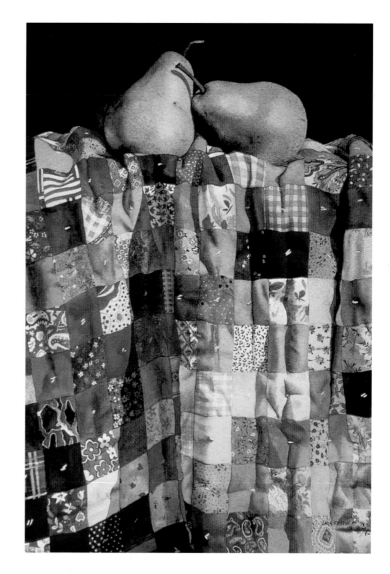

Chris Krupinski
A Pair
30" x 22" (76 cm x 56 cm)
Arches 300 lb. rough

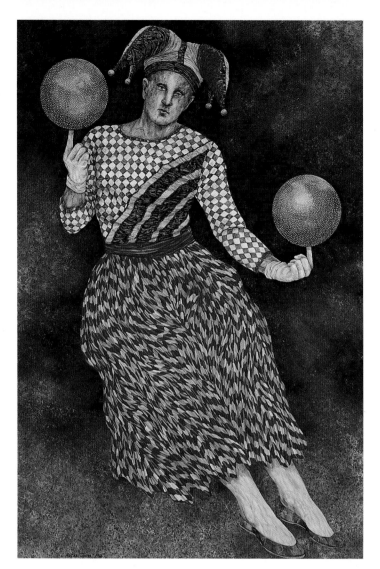

ALETHA A. JONES
To Rise Above the Level of the Fool II
40" x 27" (102 cm x 69 cm)
Crescent smooth
Watercolor and water-soluble painting
crayons

SANDRA HUMPHRIES
New Mexico Sky
30" x 22" (76 cm x 56 cm)
Arches 300 lb. cold press

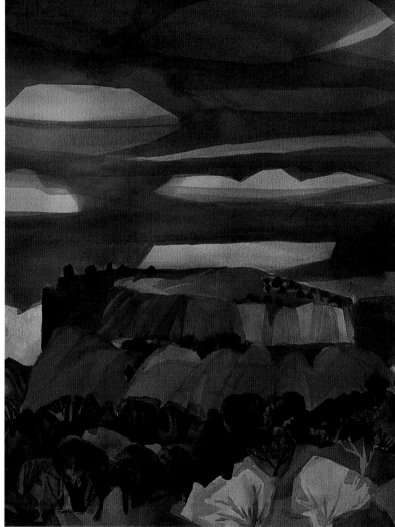

ROBERT HALLETT
Crescendo
30" x 44" (76 cm x 112 cm)
Arches 140 lb. cold press
Watercolor and acrylic

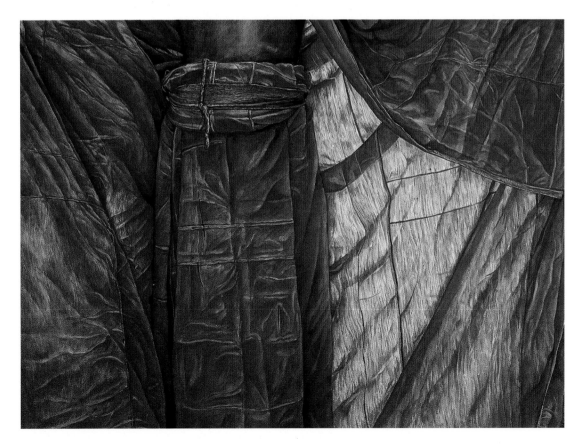

CHANG FEE-MING
In This Earth, In That Wind
22" x 30" (56 cm x 76 cm)
Schut 300 gsm

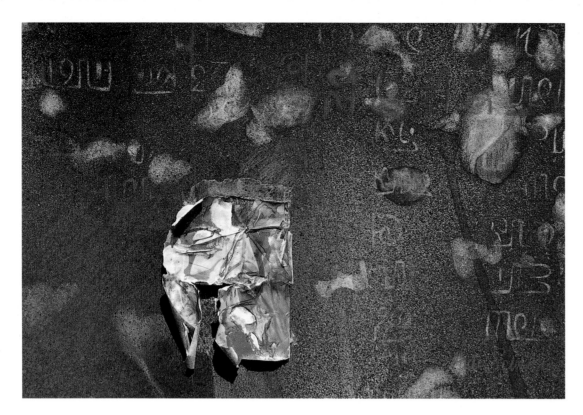

AÏDA SCHNEIDER
Ancient Rituals XII
11" x 14" (28 cm x 36 cm)
Arches 140 lb.
Watercolor, water-soluble pencil, and collage
Special Technique: Underpainted various colors
and sprayed dark colors. Lifted and wiped off
shapes and picked out details with water-soluble
pencil. Used collage for other imagery.

MARY JANE COX
Family Outing
22" x 30" (56 cm x 76 cm)
Winsor & Newton 140 lb. hot press
Watercolor, acrylic, and gouache

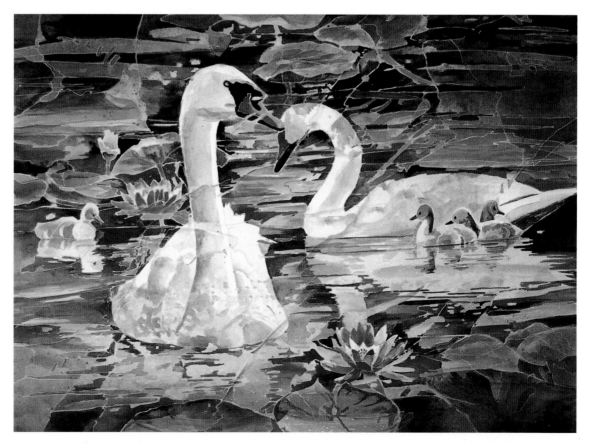

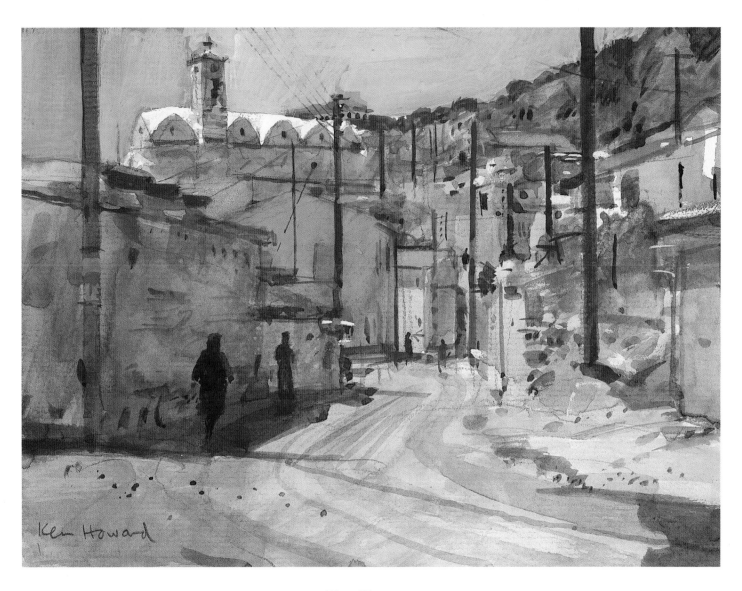

KEN HOWARD
Pissouri Village, Afternoon
7" x 9" (18 cm x 23 cm)
Canson pastel paper
Watercolor and Chinese white

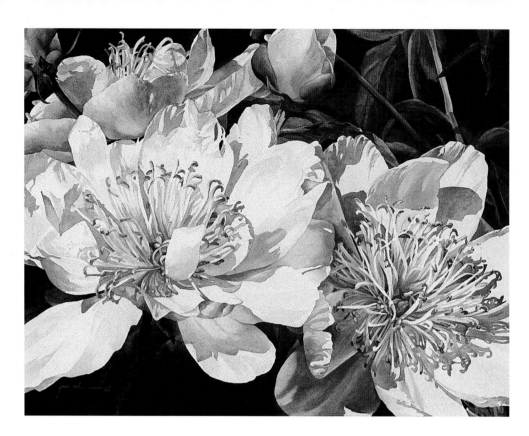

JEAN COLE
Never Bashful
22" x 30" (56 cm x 76 cm)
Fabriano Artistico 300 lb. rough

NAT LEWIS
Maine Mansard
22" x 28" (56 cm x 71 cm)
Arches 300 lb. hot press

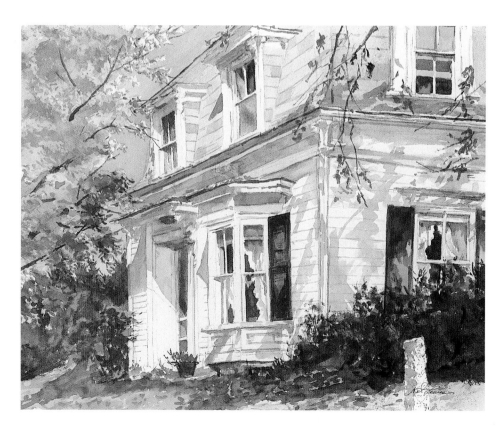

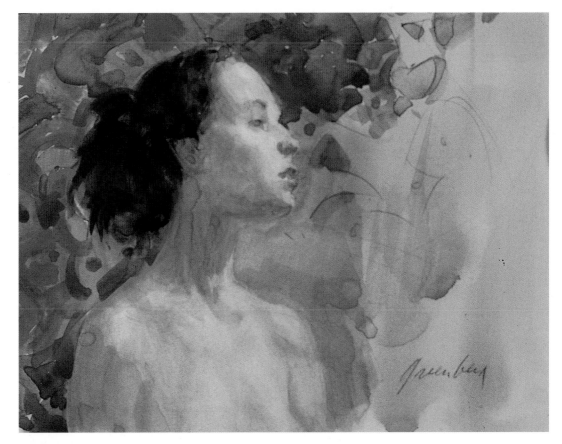

IRWIN GREENBERG
Chrissy
5" x 7" (13 cm x 18 cm)
3-ply bristol

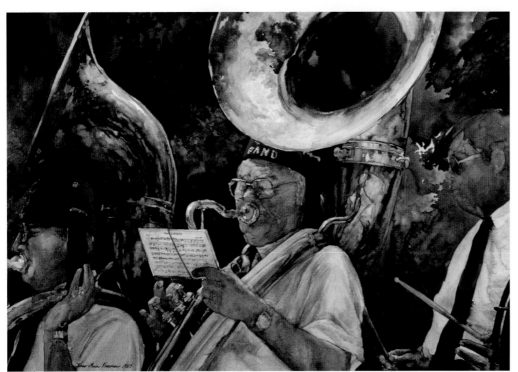

KASS MORIN FREEMAN
Boys in the Band
19" x 27" (48 cm x 69 cm)
5-ply bristol vellum

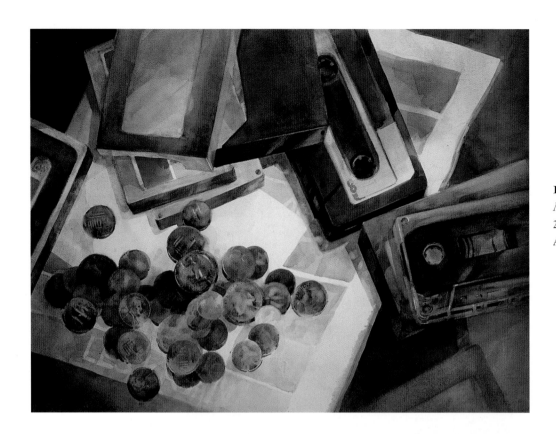

EDWARD MINCHIN
Money and Music
29" x 36" (74 cm x 91 cm)
Arches 140 lb. cold press

LOUIS STEPHEN BADAL
Nightlights—Marina Del Rey
20" x 28" (51 cm x 71 cm)
Arches 300 lb. cold press

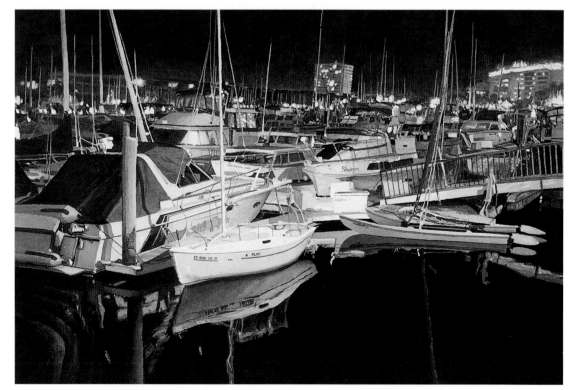

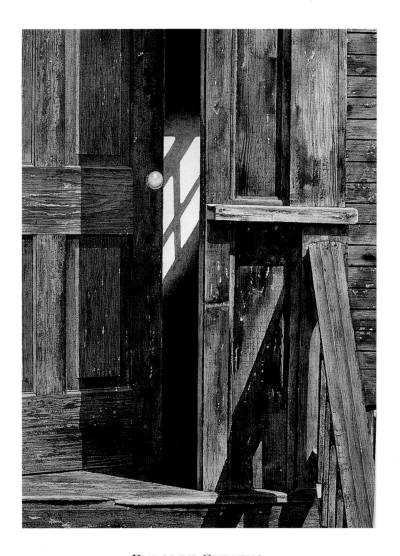

RUDOLPH OHRNING
Inside Shadow
19.25" x 14" (48 cm x 36 cm)
Arches 300 lb. cold press

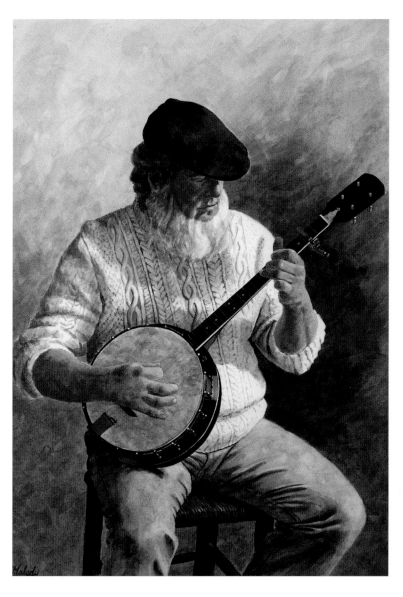

JAMES MALADY
Roger Redmond on the Banjo
28" x 20" (71 cm x 51 cm)
Waterford 140 lb. cold press
Watercolor and gouache

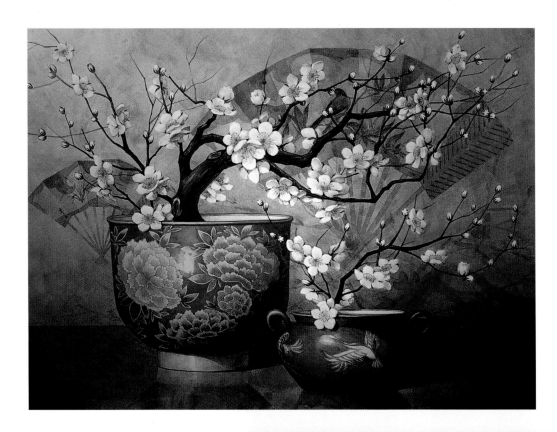

YUMIKO ICHIKAWA
Plum Flowers
18" x 24" (46 cm x 61 cm)
Strathmore 80 lb. cold press

JERRY LITTLE
Magical Forest II
30" x 38" (76 cm x 97 cm)
Arches 300 lb. cold press
Watercolor, acrylic, ink, and collage

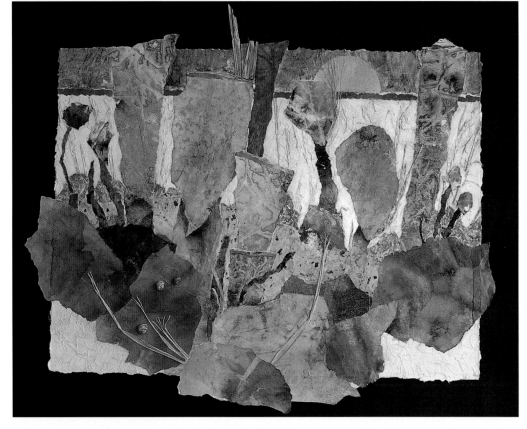

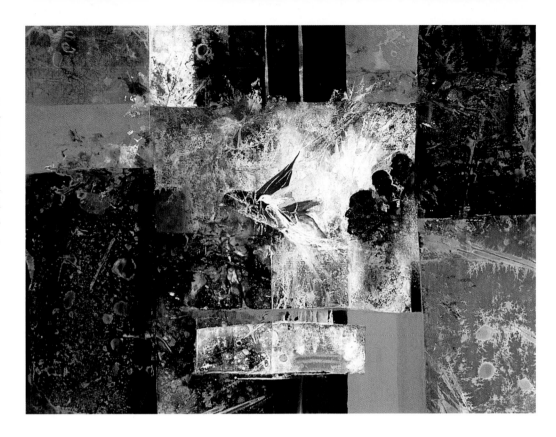

KAREN BECKER BENEDETTI
Autumn Song
22" x 30" (56 cm x 76 cm)
Strathmore Aquarius II cold press
Watercolor and acrylic
Special Technique: Paint is poured, sprayed
with water, and printed with cut plastic and
pine needles; brushes are then used to
simplify and define.

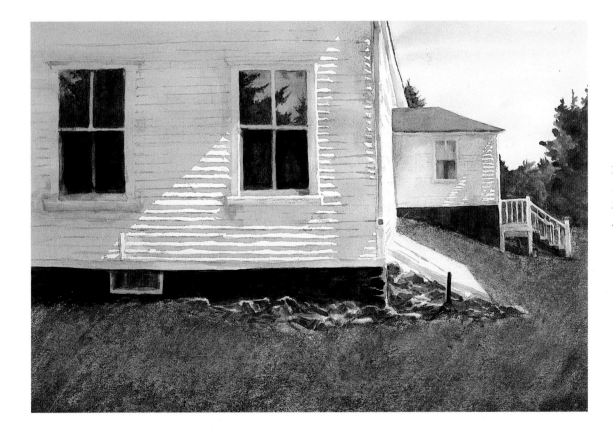

NAT LEWIS
House at Harts Neck
24" x 30" (61 cm x 76 cm)
Arches 300 lb. hot press

27

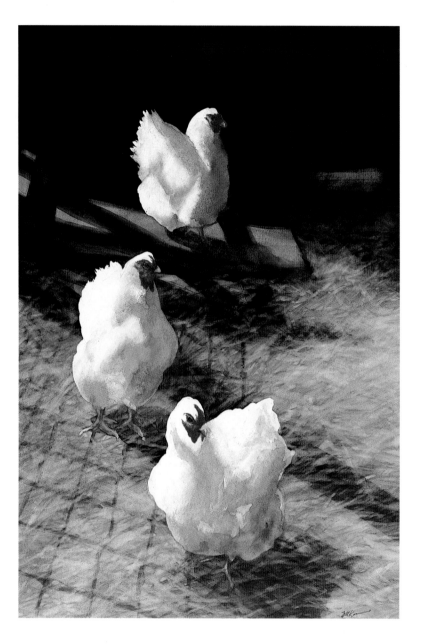

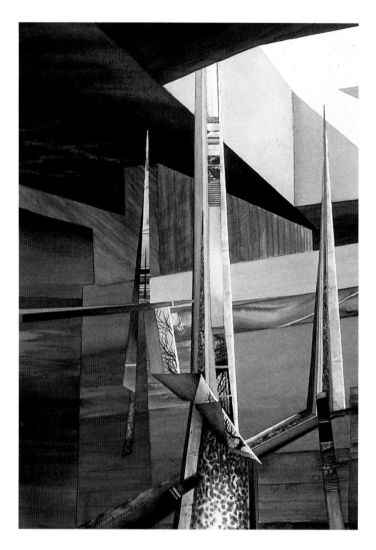

H. C. DODD
Trident
30" x 22" (76 cm x 56 cm)
300 lb. cold press

M. C. KANOUSE
Three Chickens
32" x 23" (81 cm x 58 cm)
Lanaquarelle 300 lb. cold press

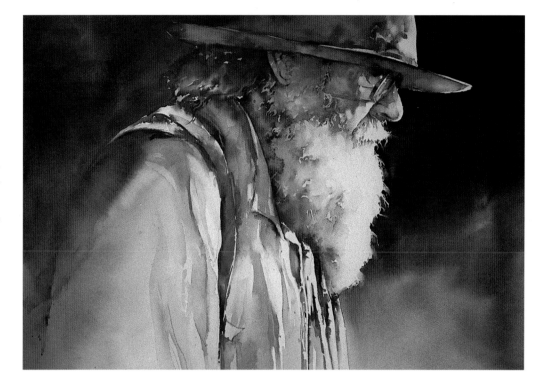

JOSEPH FETTINGIS
The Light on his Face
22" x 28" (56 cm x 71 cm)
300 lb. cold press

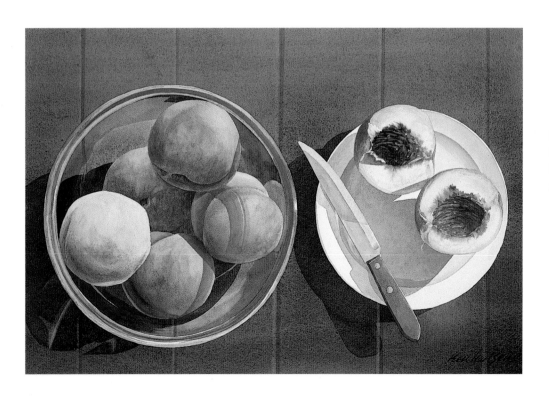

KEN HANSEN
Golden Albertas
15" x 22" (38 cm x 56 cm)
Arches 300 lb. cold press

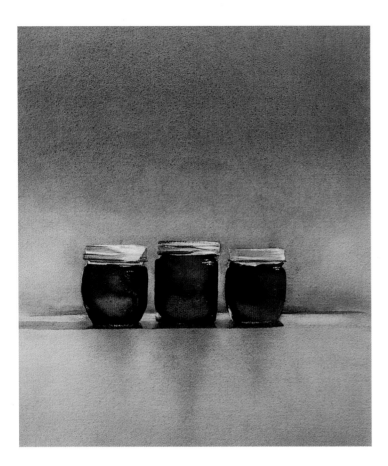

JUDITH KLAUSENSTOCK
Cherry Jam
13" x 15" (33 cm x 38 cm)
Arches 140 lb. cold press

JACK R. BROUWER
Egyptian Tea
19" x 29" (48 cm x 74 cm)
Strathmore Crescent 114 lb. cold press

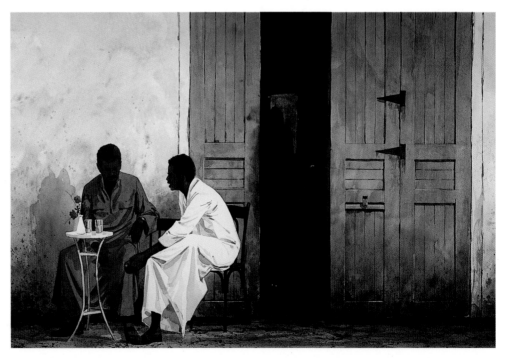

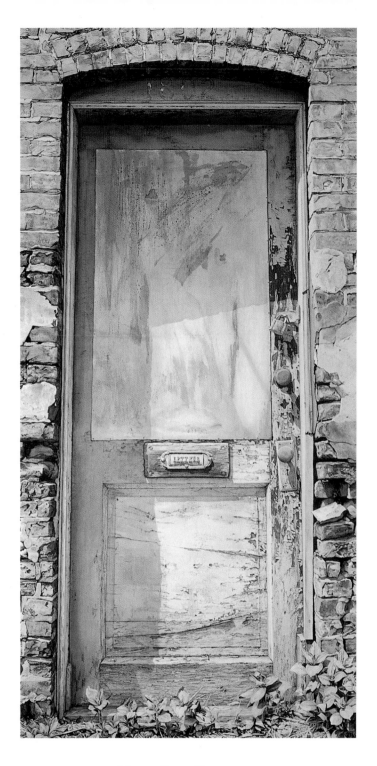

MARY LOU FERBERT
Old Door
86.5" x 42.5" (220 cm x 108 cm)
Tycore
Special Technique: Printing with wax paper.

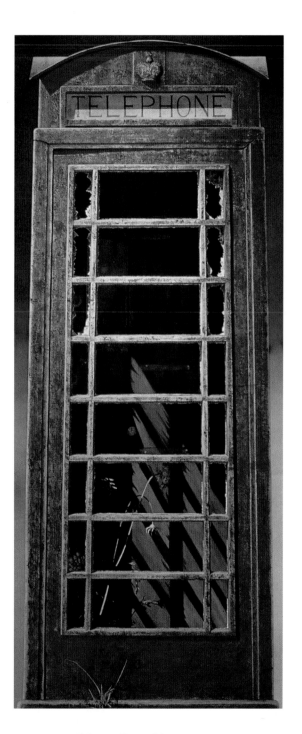

MARY LOU FERBERT
Queen Anne's Lace and English Telephone Booth
87" x 35.75" (221 cm x 91 cm)
Tycore
Special Technique: Utilized printing to simulate
the patina of the metal booth.

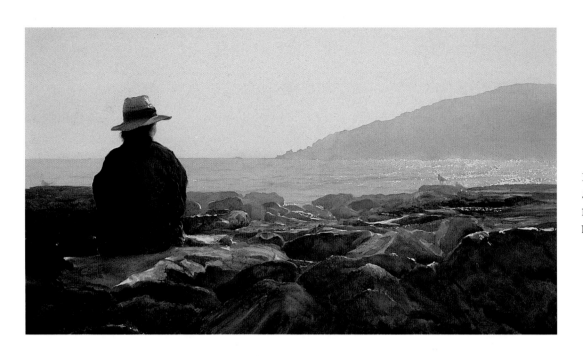

PAUL W. NIEMIEC, JR.
Sea Jewels
18" x 30" (46 cm x 76 cm)
Lanaquarelle 140 lb. cold press

ROBERT SAKSON
Artist's Table
22" x 30" (56 cm x 76 cm)
Arches 140 lb. rough

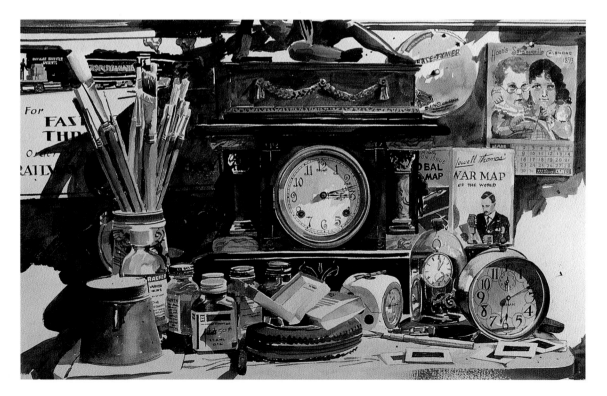

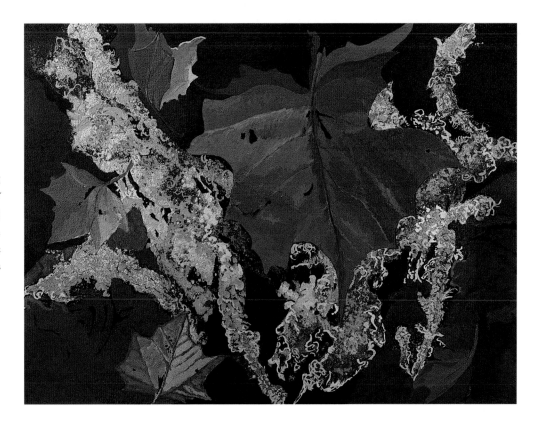

MARILYNN R. BRANHAM
Sycamore Seasons IV
22" x 30" (56 cm x 76 cm)
Arches 300 lb.
Watercolor, acrylic, and metallic
watercolor powders

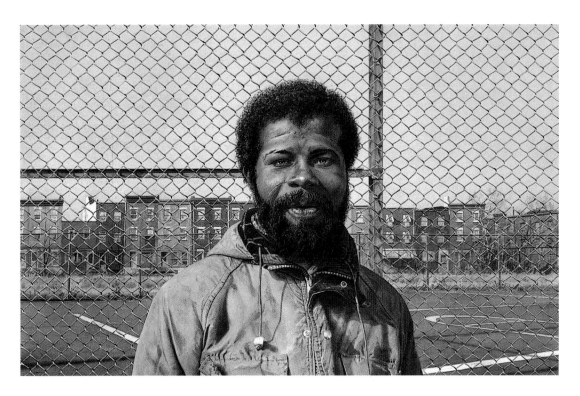

JAMES TOOGOOD
Kindred Spirit
14.5" x 20.5" (37 cm x 51 cm)
Arches 140 lb. cold press

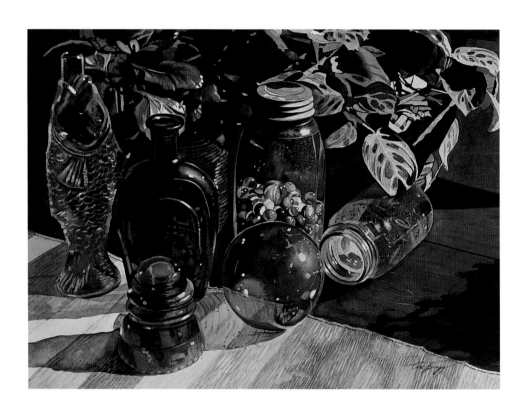

EVE BRAGG
Glass Menagerie
22" x 30" (56 cm x 76 cm)
Arches 300 lb.

MARLENE A. BOONSTRA
Collective Input
19" x 29" (48 cm x 74 cm)
Cold press

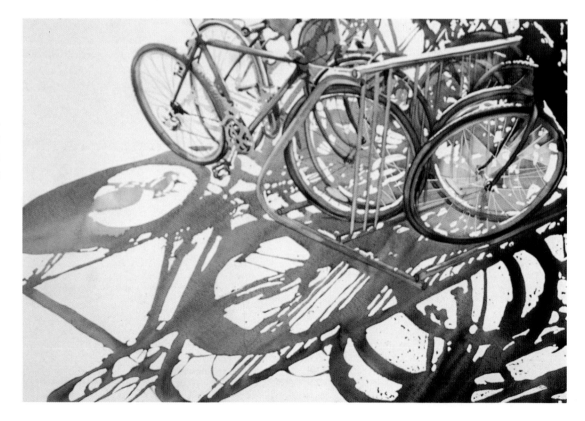

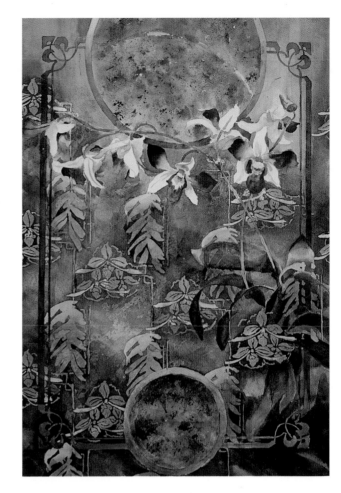

GEORGIA A. NEWTON
Orchid
30" x 22" (76 cm x 56 cm)
Very soft paper
Watercolor and acrylic

ALICE W. WEIDENBUSCH
Lancaster Cottage
3.5" x 5" (9 cm x 13 cm)
Arches 140 lb. cold press

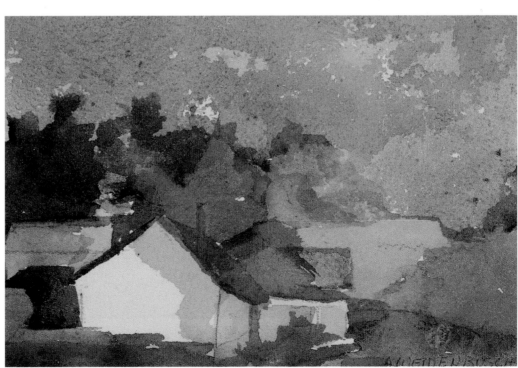

JOSEPH MANNING

Lady in Red

10.5" x 10.5" (27 cm x 27 cm)

Arches 140 lb. hot press

Watercolor, gouache, and egg-mixed pigment

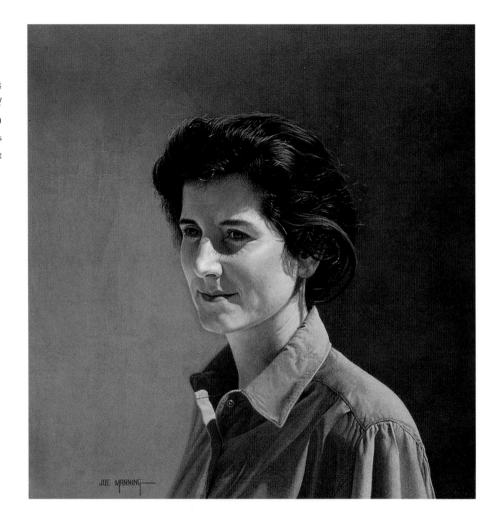

ALEXIS LAVINE

Barnside

11" x 30" (28 cm x 76 cm)

140 lb. cold press

Watercolor and watercolor pencils

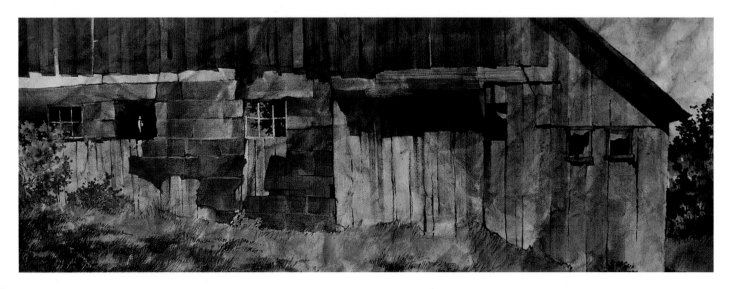

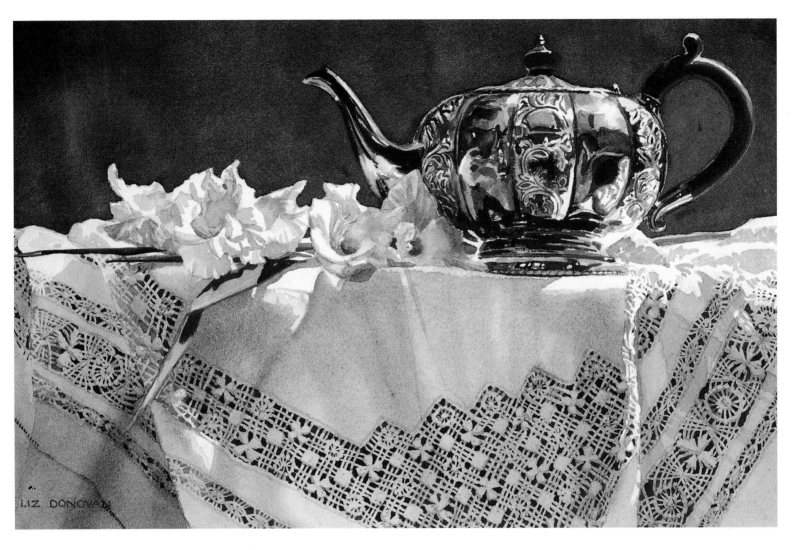

LIZ DONOVAN
Teapot with Gladiola
10.5" x 16" (27 cm x 41 cm)
Arches 300 lb. cold press

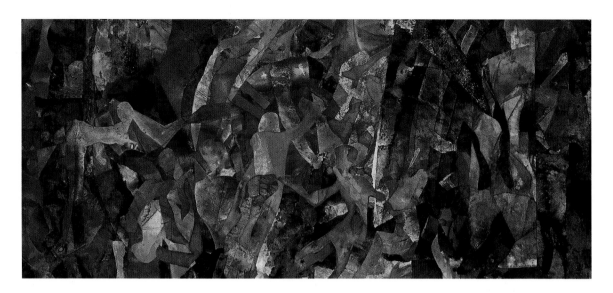

ALLAN HILL
Spirit Dance
13" x 30" (33 cm x 76 cm)
Arches 140 lb. hot press
Watercolor and acrylic collage

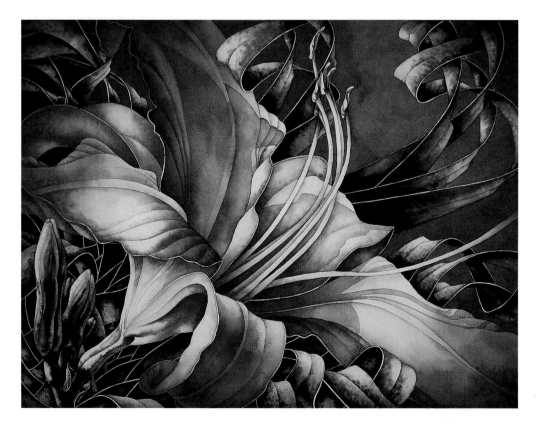

JOHN POLLOCK
Day Lily with a Twist
22.5" x 30" (57 cm x 76 cm)
Winsor & Newton 260 lb. cold press
Special Technique: Colors were glazed over one
another to achieve the final result; none of the
colors were mixed on the palette.

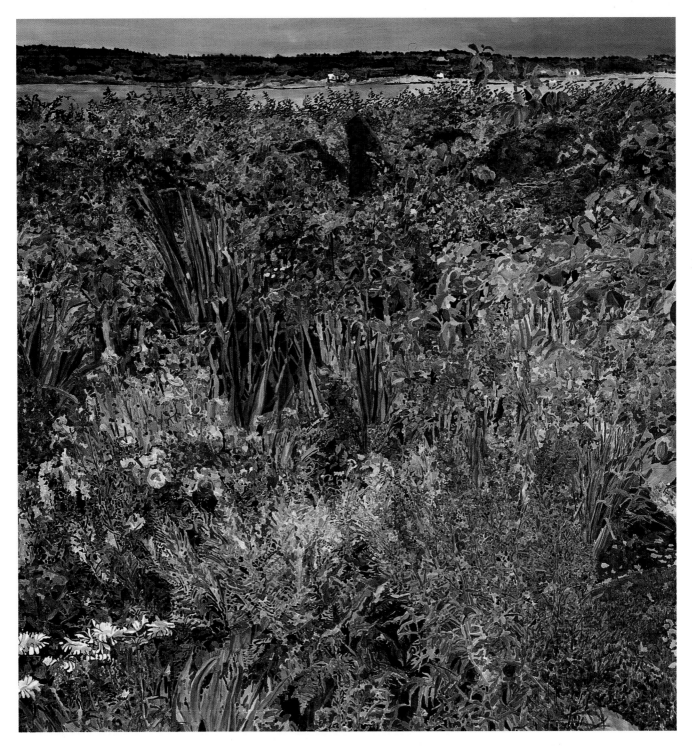

JUDITH STEELE GAITEMAND
Ceilia Beaux'
42" x 42" (107 cm x 107 cm)
Silk
Watercolor and silk dyes

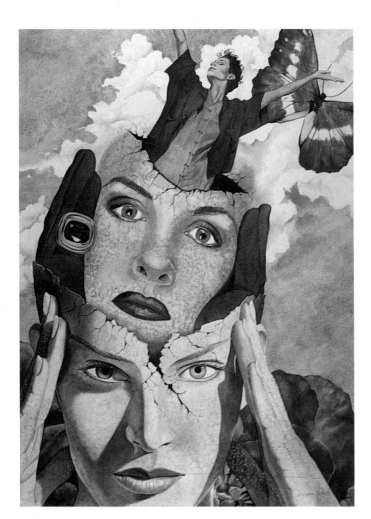

DEBORAH KAPLAN EVANS
Chrysalis
30" x 23" (76 cm x 58 cm)
Arches 300 lb. hot press

CONNIE LUCAS
The Hideaway
29.5" x 21.5" (75 cm x 55 cm)
Arches 140 lb. cold press

JoRene Newton
Behold the Awe of Our Being
19" x 27" (48 cm x 69 cm)
Strathmore hot press 100% rag
Watercolor and acrylic

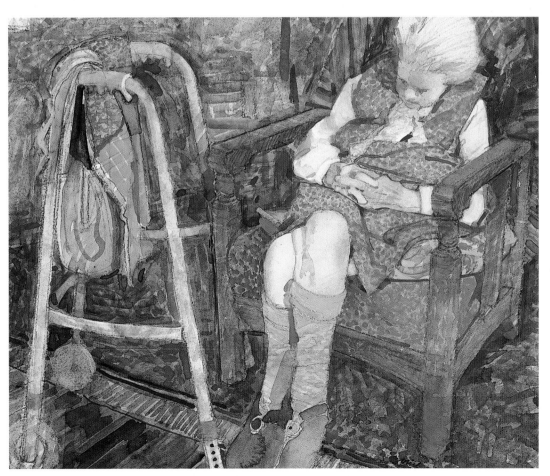

Michael Whittlesea
The Walking Frame
16" x 17" (41 cm x 43 cm)
Arches Aquarelle 90 lb. rough

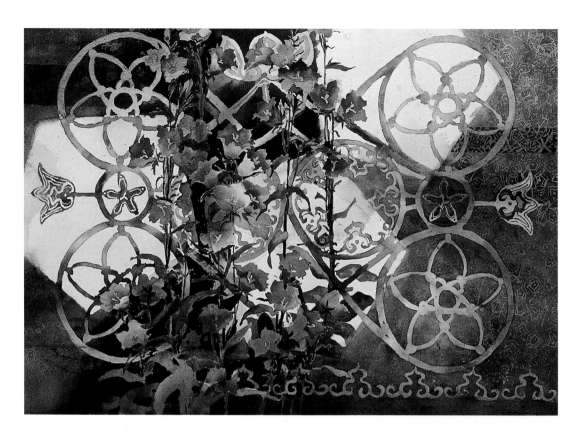

GEORGIA A. NEWTON
Campanula
22" x 30" (56 cm x 76 cm)
140 lb. cold press

GERALDINE McKEOWN
Winnowing Basket
20.5" x 28" (52 cm x 71 cm)
140 lb. cold press

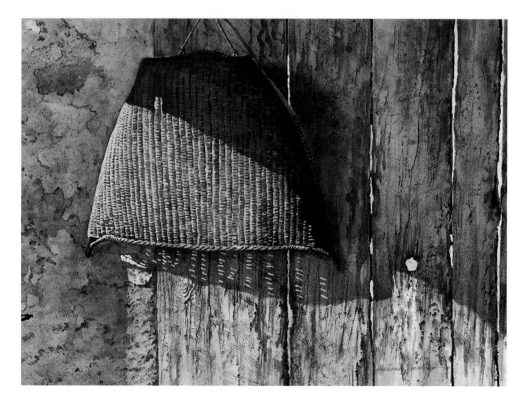

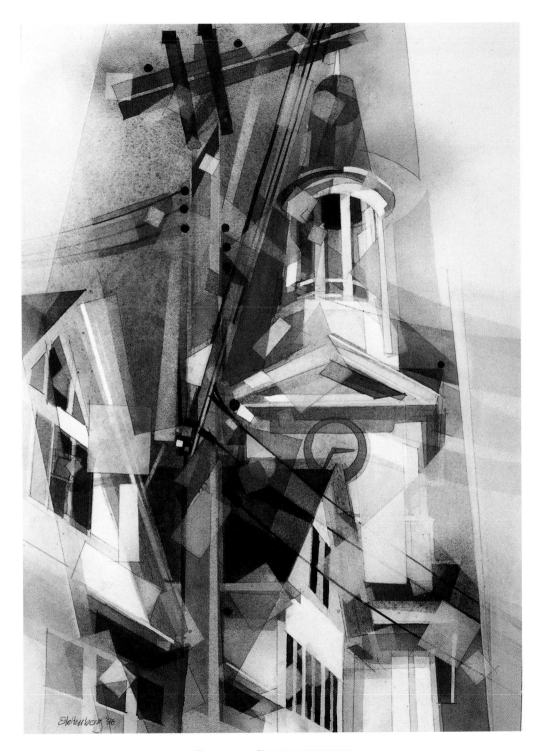

DONALD STOLTENBERG

Wellfleet Sky

Arches 140 lb. cold press

Watercolor and Chinese white

43

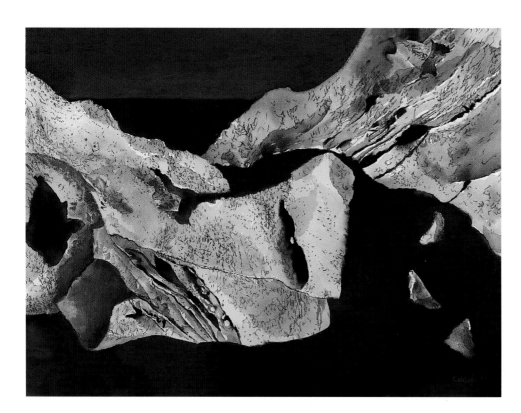

Judy Cassab
Rill—Rainbow Valley
29" x 40" (74 cm x 102 cm)
Arches
Watercolor and gouache

Gloria Baker
The Dedicated
32" x 40" (81 cm x 102 cm)
Arches 140 lb. cold press

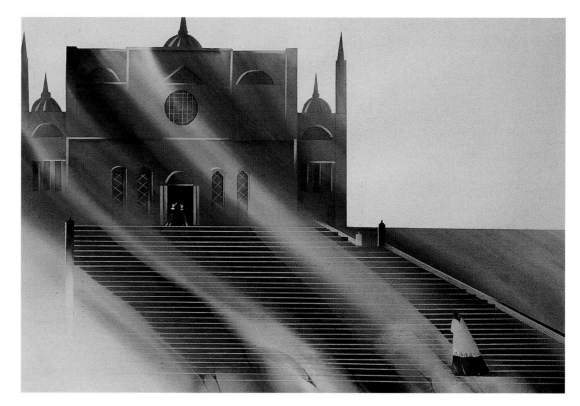

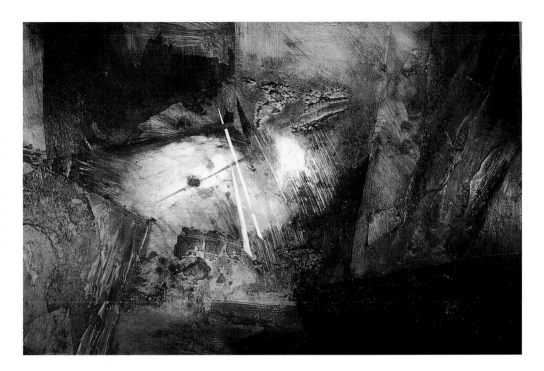

BETTY CARMELL SAVENOR
Inner Vision
30" x 40" (76 cm x 102 cm)
3-ply board
Watercolor and acrylic textures
Special Technique: Surface layer of board
was torn for varied levels of texture
and then glazed. Linear effects
were acheived by scratching wet paint.

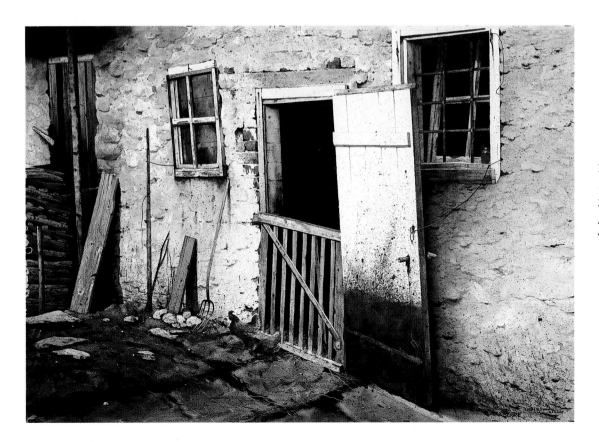

LORING W. COLEMAN
16th Century Farm—Austria
26.5" x 39" (67 cm x 99 cm)
Arches 110 lb. cold press
Watercolor and acrylic

45

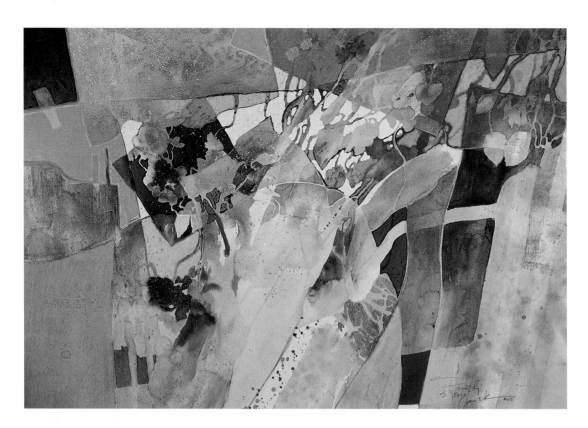

DOROTHY GANEK
Breaking Away
36" x 42" (91 cm x 107 cm)
Arches 260 lb. hot press
Watercolor and acrylic
Special Technique: Wax paper was
laid into wet pigment and left to dry.

JOHN T. SALMINEN
Lake & Wells, Chicago, Illinois
25" x 35" (64 cm x 89 cm)
Arches 140 lb. cold press

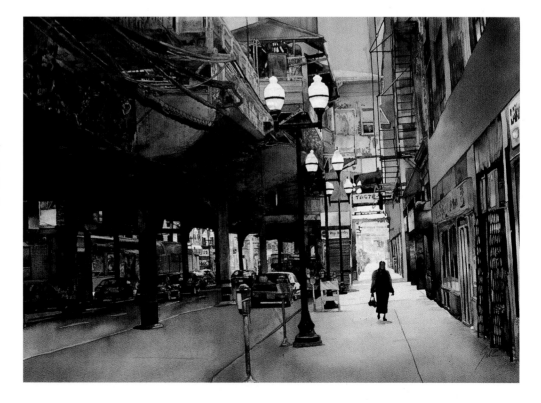

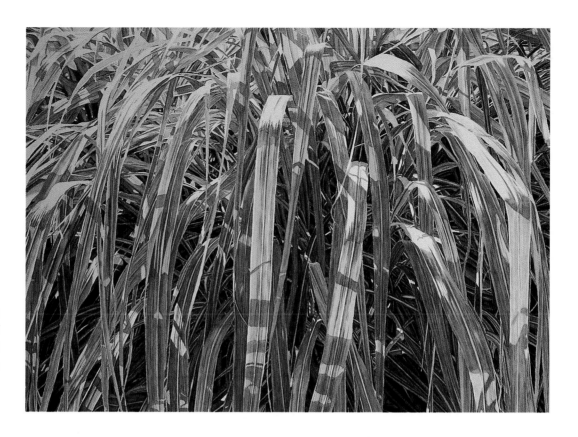

DOROTHY D. GREENE
Citronella II
29" x 41" (74 cm x 104 cm)
Arches 300 lb. rough

BENJAMIN MAU
Night Flower
30" x 40" (76 cm x 102 cm)
Arches 140 lb. cold press

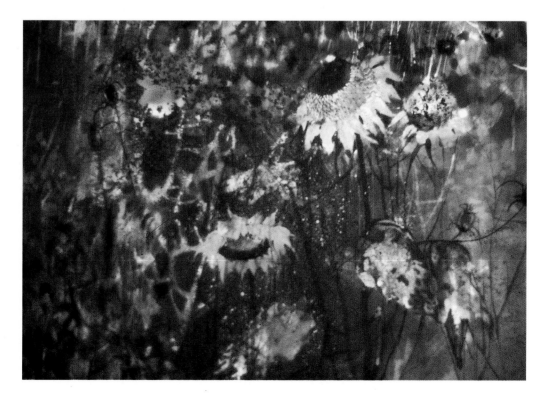

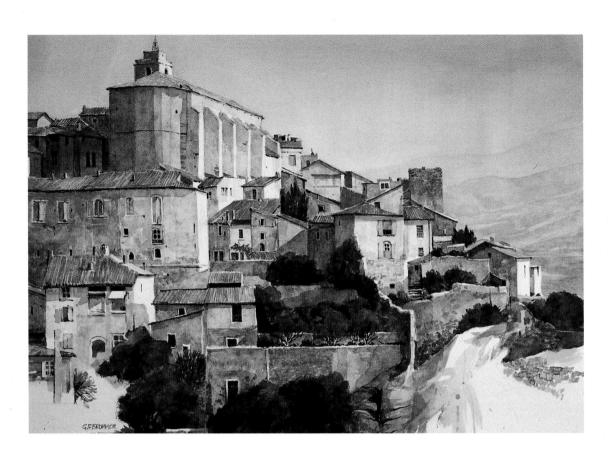

GERALD F. BROMMER
View of Gordes
22" x 30" (56 cm x 76 cm)
Lanaquarelle 300 lb. rough

HELEN GARRETSON
Clean Sweep at the Railroad Museum
13" x 21" (33 cm x 53 cm)
Arches 140 lb.

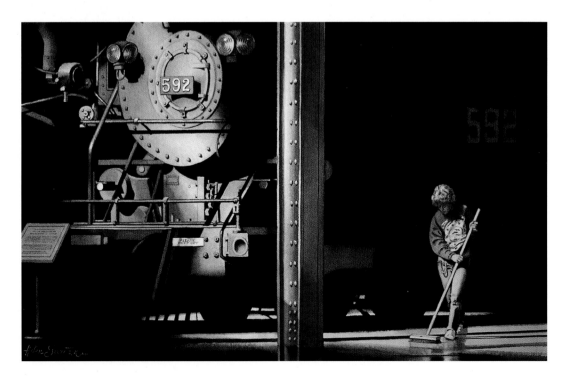

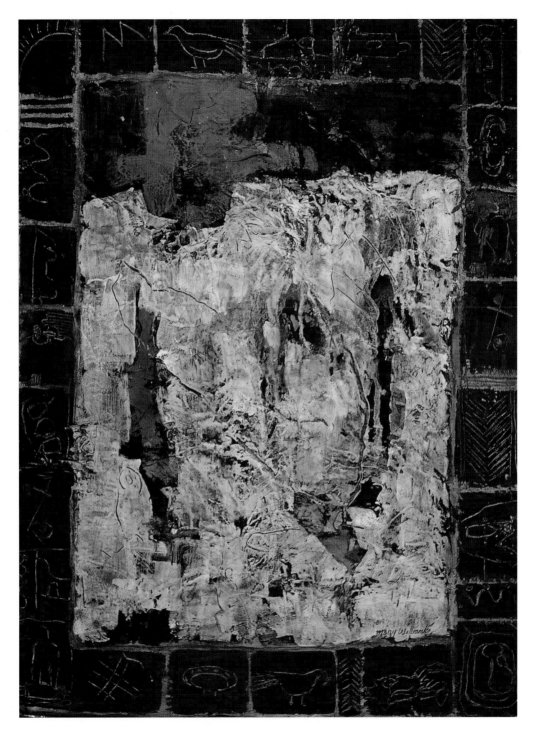

MARY WILBANKS

Visible Mystery

34" x 25" (86 cm x 64 cm)

Handmade paper

Watercolor, acrylic, collage, and watercolor pencils

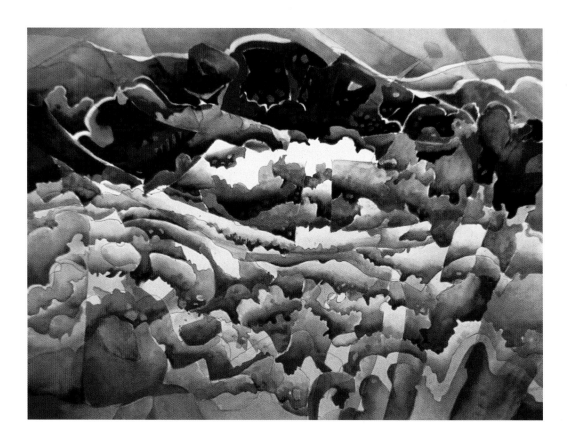

JANE E. JONES
Hawaii Scape I
22" x 30" (56 cm x 76 cm)
Arches 140 lb. cold press

GREG TISDALE
Medusa Challenger
17" x 27.5" (43 cm x 70 cm)
140 lb. medium

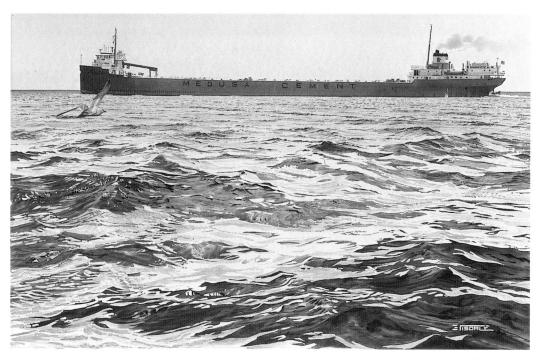

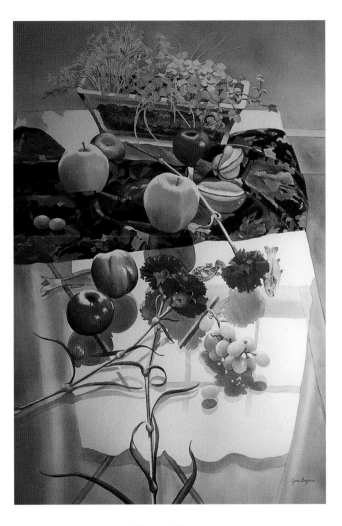

JANE FREY
Herb Garden and Red Carnations
36" x 26" (91 cm x 66 cm)
Arches Double Elephant cold press

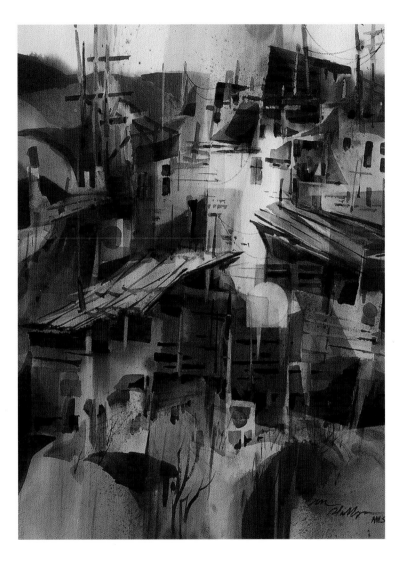

DICK PHILLIPS
In Search of El Dorado
29" x 21" (74 cm x 53 cm)
Arches 140 lb. cold press

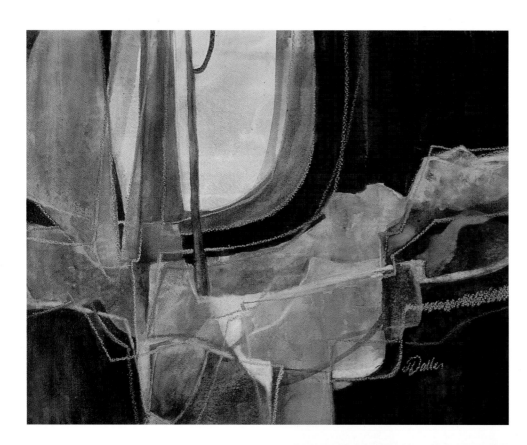

DOROTHY B. DALLAS
New Forest II
15" x 19" (38 cm x 48 cm)
Arches 140 lb. cold press
Watercolor, gouache, and watercolor crayon

SCOTT MOORE
T.V. Dinner
22" x 30" (56 cm x 76 cm)
Arches 140 lb. cold press

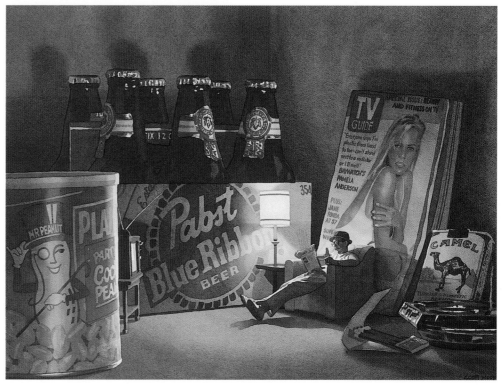

DOUGLAS WILTRAUT
Mare's Tail
38" x 29" (97 cm x 74 cm)
Arches Double Elephant 300 lb.

EDWIN L. JOHNSON
Grandma's Quilt
19" x 13" (48 cm x 33 cm)
Crescent 114 lb. cold press

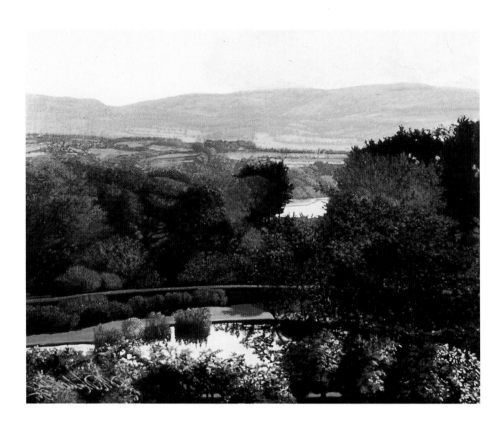

MICHAEL L. NICHOLSON
On Stage at the Kiamichi
11" x 14" (28 cm x 36 cm)
2-ply bristol with gesso
Watercolor, acrylic, and graphite

WILL BULLAS
Fool's Time...
20" x 20" (51 cm x 51 cm)
Illustration board

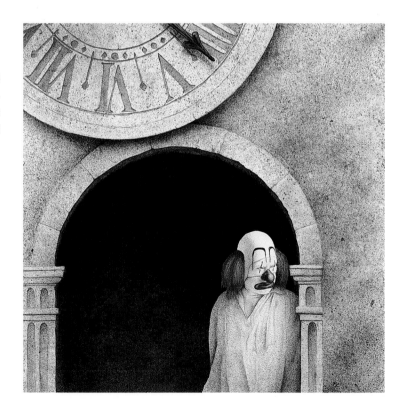

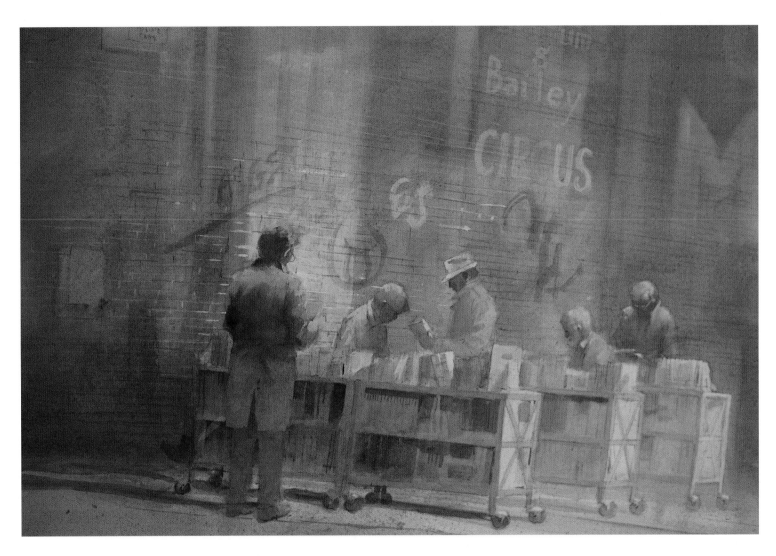

GEORGE SHEDD
Bookworms
22" x 30" (56 cm x 76 cm)
Bainbridge cold press
Watercolor and gouache

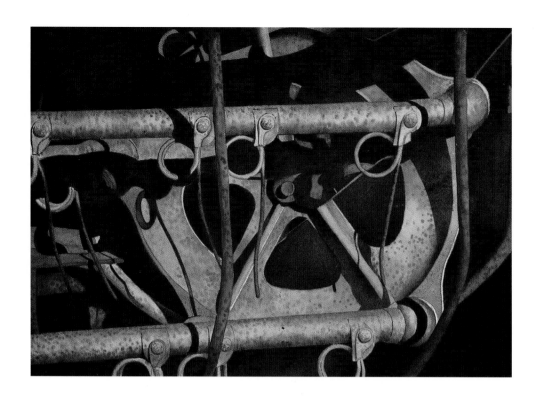

JOHN BRYANS
Rural Power
29.5" x 40" (75 cm x 102 cm)
Arches 115 lb. rough

MILES G. BATT, SR.
Indifferent Love
17" x 23" (43 cm x 58 cm)
Arches 140 lb. hot press

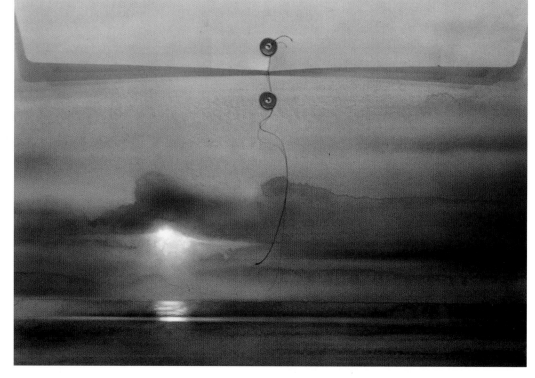

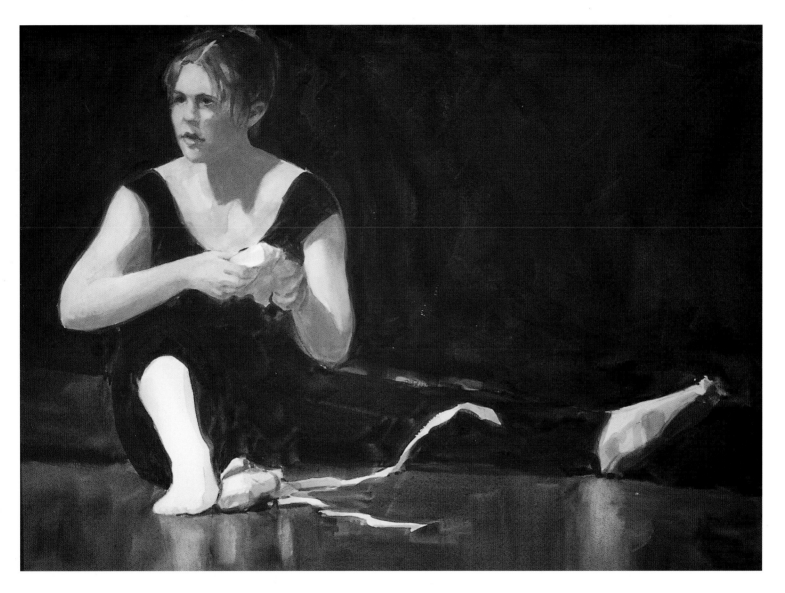

MARTHA MANS
Backstage
20" x 26" (51 cm x 66 cm)
Arches 300 lb. hot press

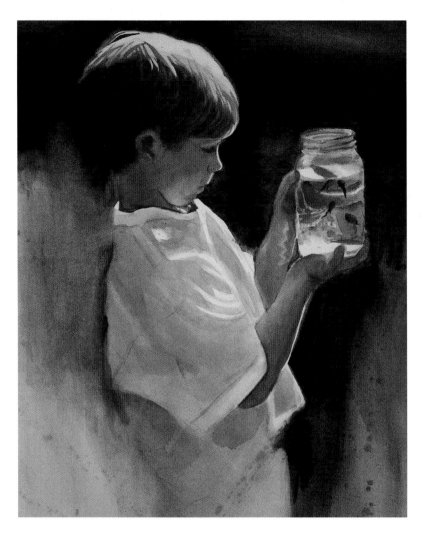

PAT CAIRNS
Pollywog Jar
30" x 22" (76 cm x 56 cm)
Arches 140 lb. hot press

JOHN MCIVER
Sequences 43
32" x 24" (81 cm x 61 cm)
Arches 260 lb. cold press
Watercolor and acrylic

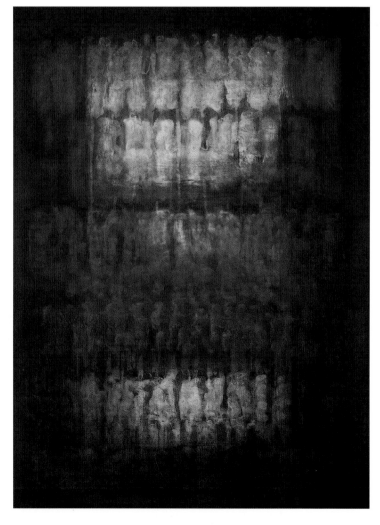

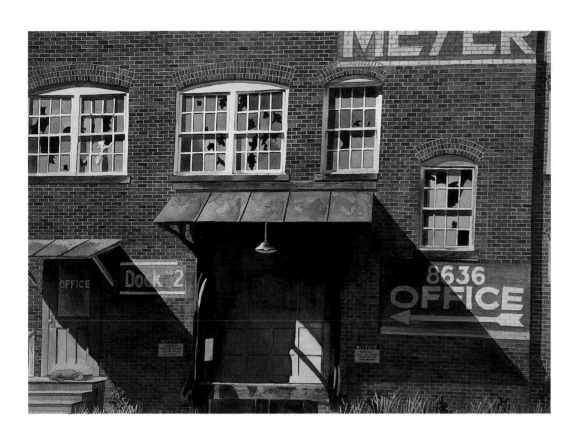

MORRIS MEYER
Dock 2
20" x 28" (51 cm x 71 cm)
Arches 300 lb.

KEN SCHULZ
Over Still Waters
14" x 18.5" (36 cm x 47 cm)
Arches 300 lb. cold press
Watercolor and opaque

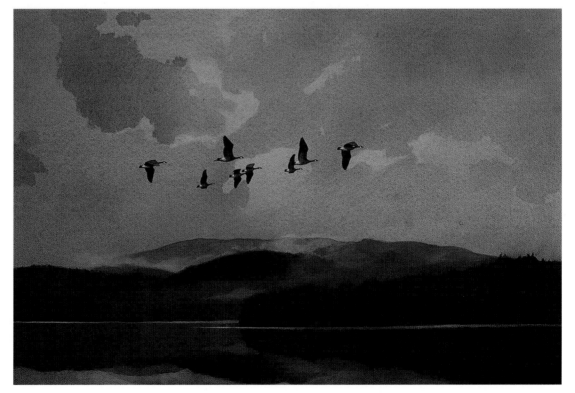

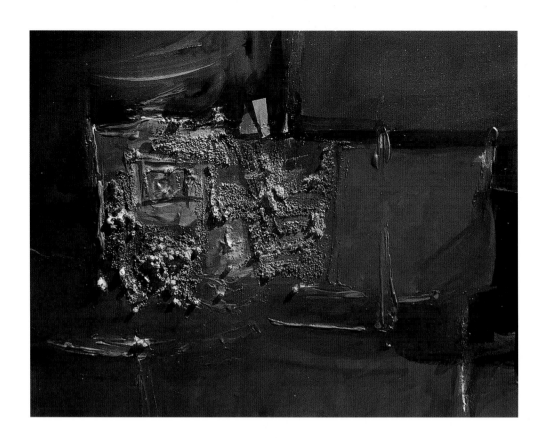

ROBERT S. OLIVER
Cardinal's Table
10.5" x 13.5" (27 cm x 34 cm)
Crescent 100 lb.
Watercolor, liquid acrylic, gesso,
modeling paste, and particle collage
in paste

BARBARA BURWEN
Heavenly Body
12" x 17" (30 cm x 43 cm)
140 lb. rough
Watercolor, water-based ink, mica,
sand patterns, and ink overlays

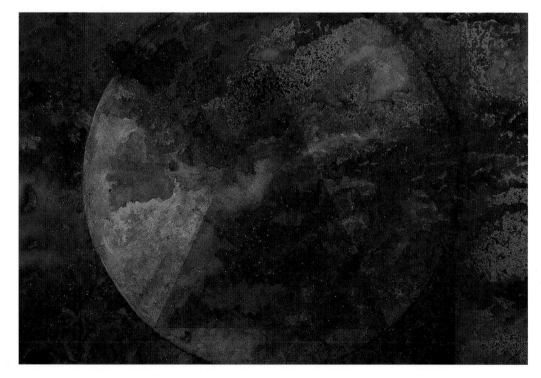

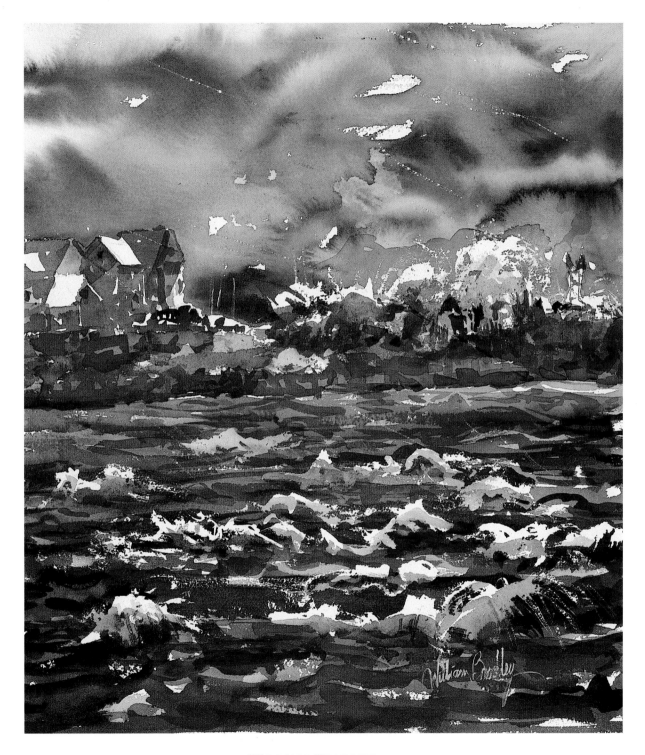

WILLIAM BRADLEY

Nor'easter—Rockport Harbor

22" x 15.5" (56 cm x 38 cm)

Arches 300 lb.

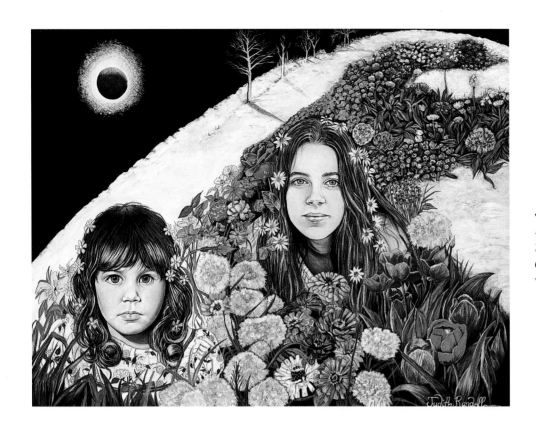

JUDITHE RANDALL
Les Soeurs En Blume
20" x 26" (51 cm x 66 cm)
Crescent
Watercolor, acrylic, and ink

BARBARA SORENSON RAMBADT
Fresh from the Garden
21" x 29" (53 cm x 74 cm)
Arches 300 lb.

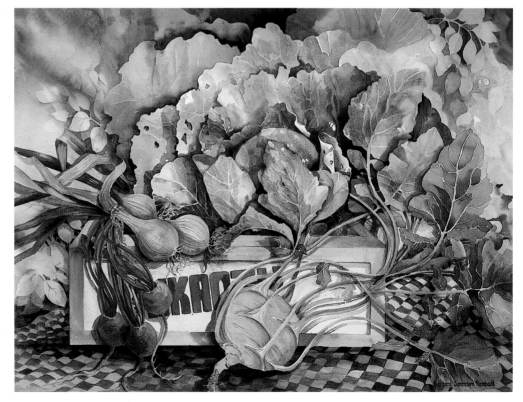

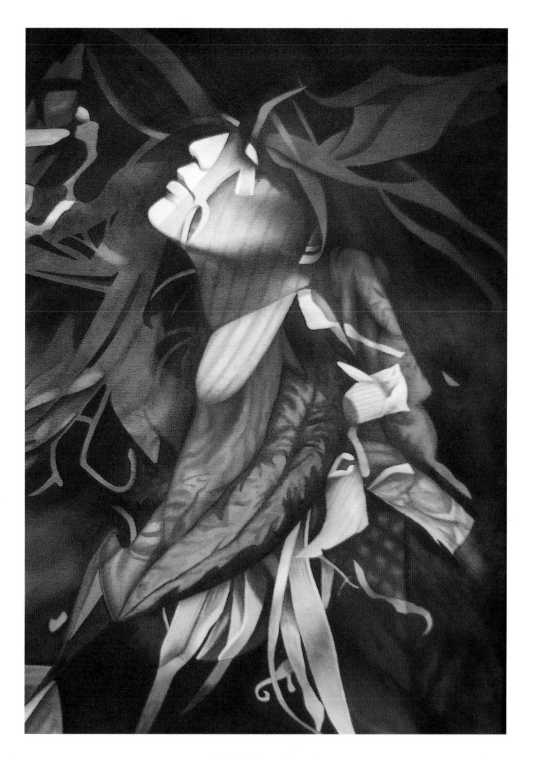

RICH ERNSTING

Spirits of the Past

25" x 37" (94 cm x 64 cm)

Arches 555 lb. cold press

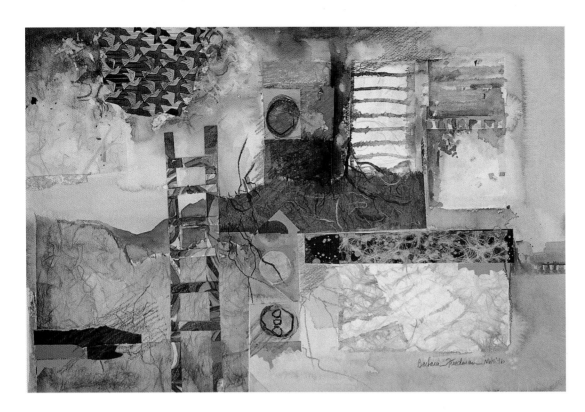

BARBARA FREEDMAN
Ladder on the Left
22" x 30" (56 cm x 76 cm)
Fabriano 300 lb.
Watercolor, oriental rice papers,
prepainted watercolor paper for
collage, watercolor, gouache,
watercolor pencils, and
watercolor crayons

RANULPH BYE
Reconstruction—Union Mills
22" x 38" (56 cm x 97 cm)
Arches cold press
Watercolor and oil

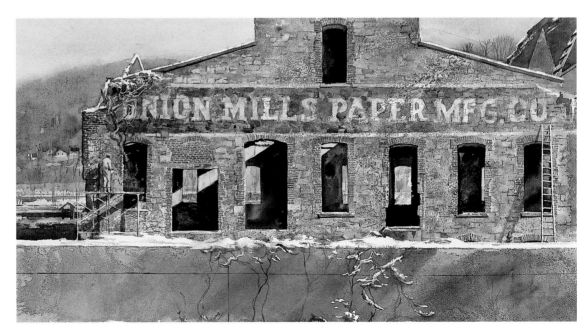

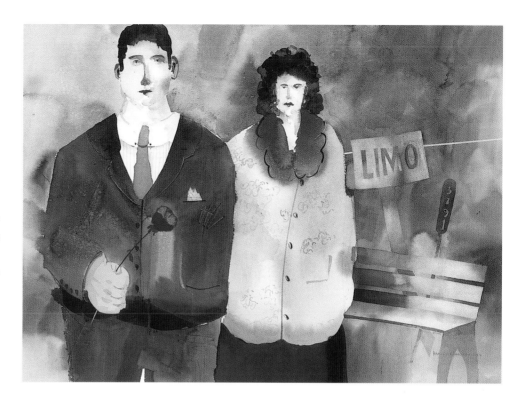

HAROLD WALKUP
On the Town
22" x 30" (56 cm x 76 cm)
Arches 140 lb. rough

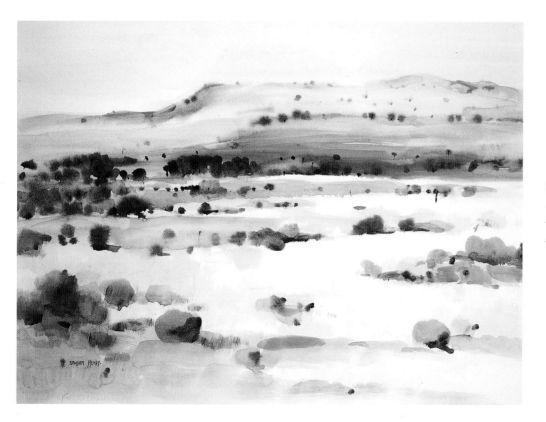

SANDRA HENDY
Broken Hill Outback
40" x 34" (102 cm x 86 cm)
Arches 600 gsm hot press

65

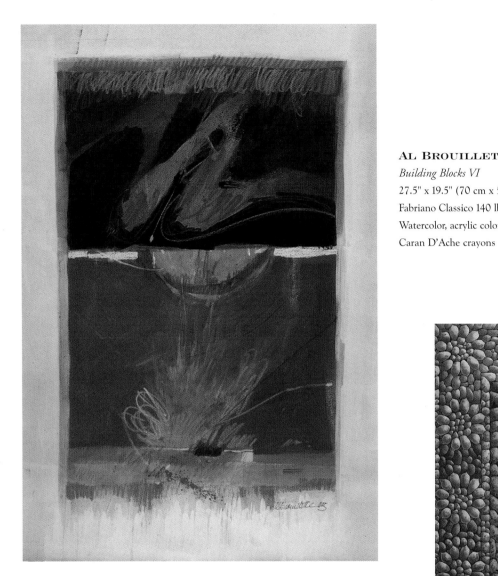

AL BROUILLETTE
Building Blocks VI
27.5" x 19.5" (70 cm x 50 cm)
Fabriano Classico 140 lb.
Watercolor, acrylic color pencils, and
Caran D'Ache crayons

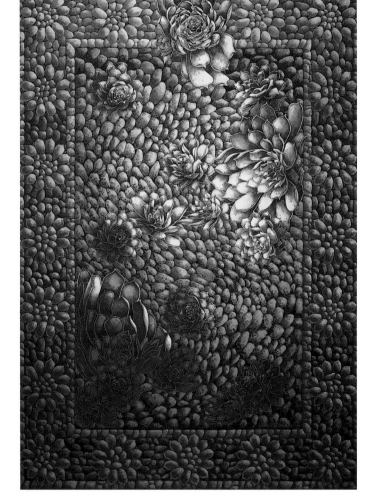

JOHN POLLOCK
Pattern of Eight
42" x 30" (107 cm x 76 cm)
Arches 555 lb. cold press
Special Technique: Colors were
glazed over one another to achieve
the final result; none of the colors
were mixed on the palette.

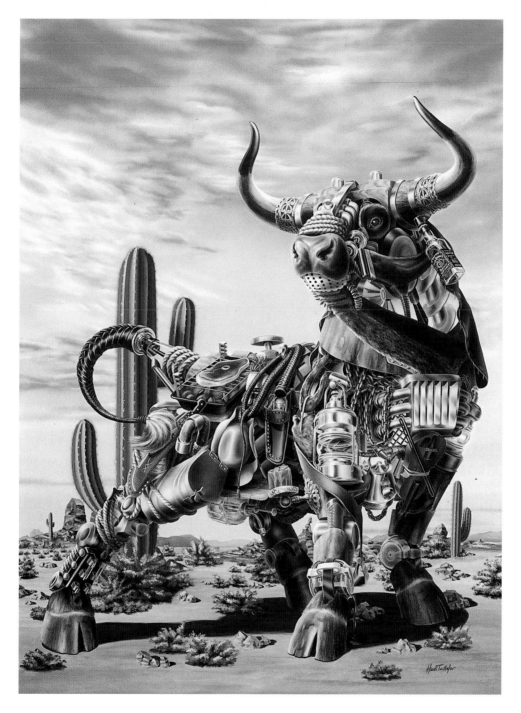

HEIDI TAILLEFER

Harbinger's Tail

30" x 40" (76 cm x 102 cm)

High-Art 27 lb.

Watercolor and acrylic

Special Technique: The metal and clouds were airbrushed with liquid acrylics to soften the surfaces.

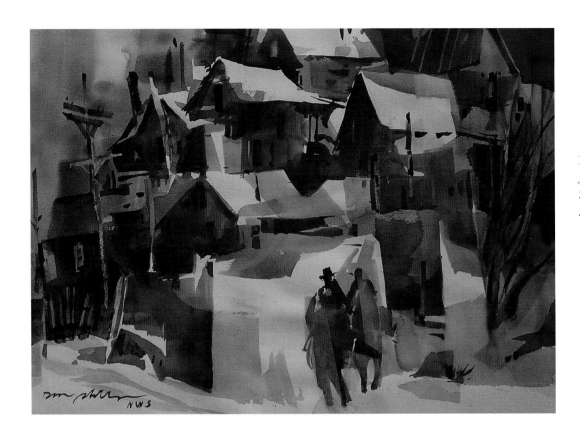

DICK PHILLIPS
Jerome Stack
21" x 29" (53 cm x 74 cm)
Arches 140 lb. cold press

PAUL W. NIEMIEC, JR.
Pines and Straw
20" x 30" (51 cm x 76 cm)
Strathmore 3-ply bristol plate finish

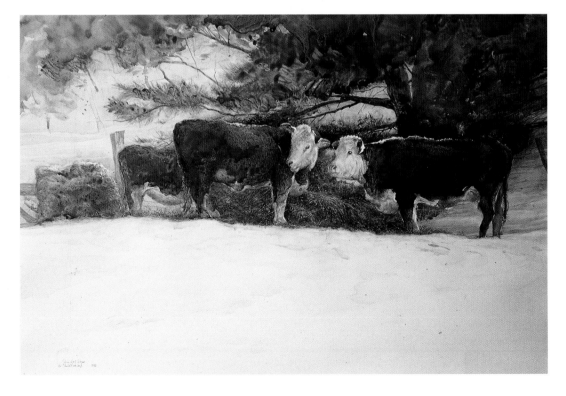

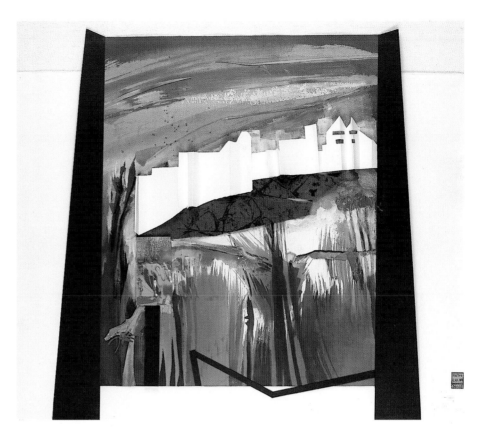

RUTH L. ERLICH
Watercolors: Third Dimensions VI
32.5" x 38" (83 cm x 97 cm)
140 lb. rough
Watercolor and diluted fabric dye

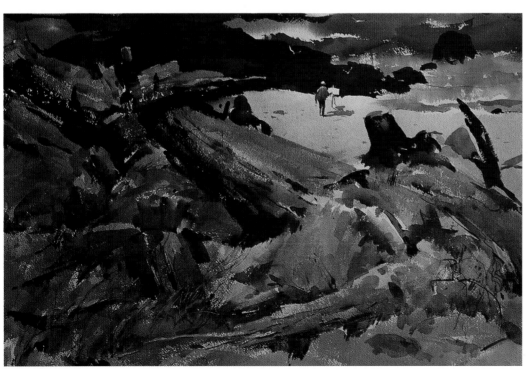

VERNON NYE
East of Terrebon
22" x 30" (56 cm x 76 cm)
Arches 400 lb. rough

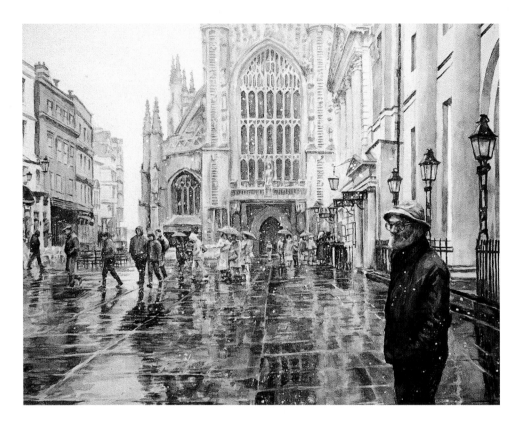

JONATHAN BLATT
Snowfall at Bath Abbey
24.5" x 27.5" (62 cm x 70 cm)
Arches 140 lb. cold press

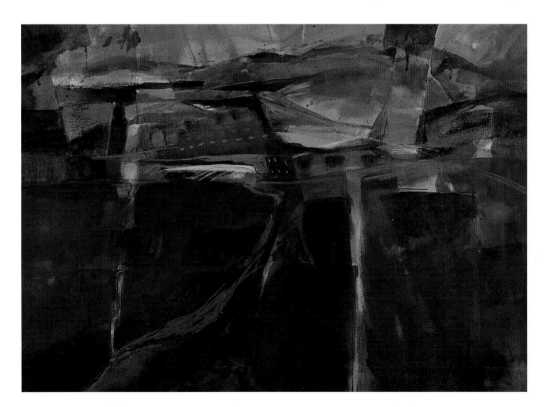

BEVERLY GROSSMAN
Born of Stone
22" x 30" (56 cm x 76 cm)
140 lb. cold press
Watercolor, acrylic pigment, and pastel

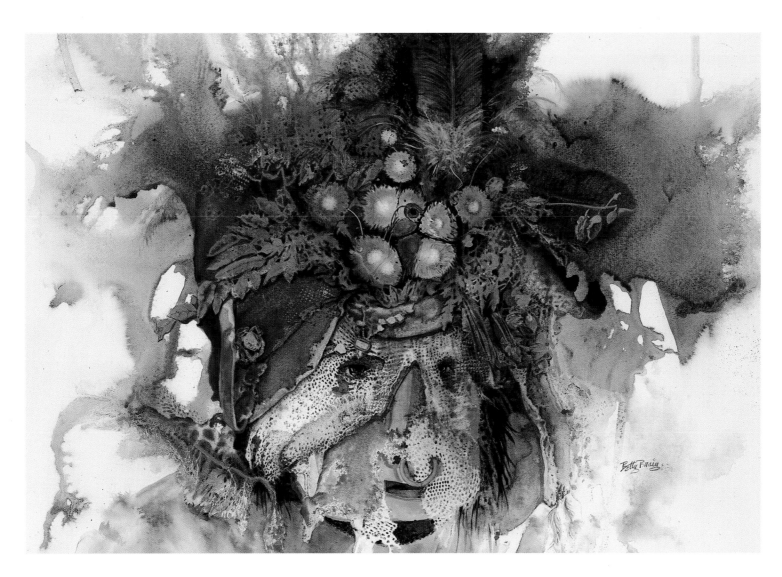

BETTY BRAIG

The Mask

30" x 40" (76 cm x 102 cm)

2-ply hot press 100% rag

Watercolor and acrylic

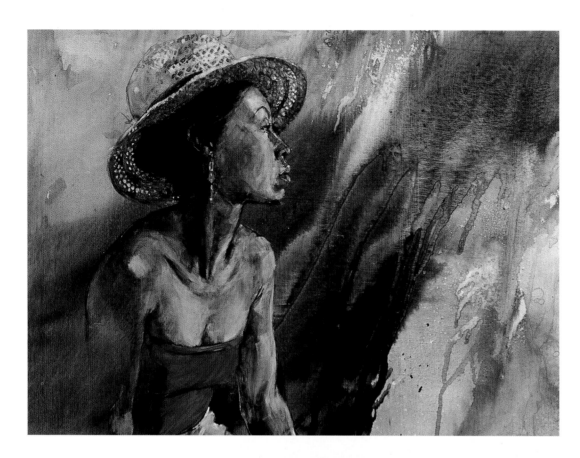

SUSAN HOLEFELDER
Gwen
20" x 25" (56 cm x 64 cm)
Crescent 100 lb. cold press

MARGARET LAURIE
My Kwan Chow Period
21" x 29" (53 cm x 74 cm)
Arches 260 lb. cold press

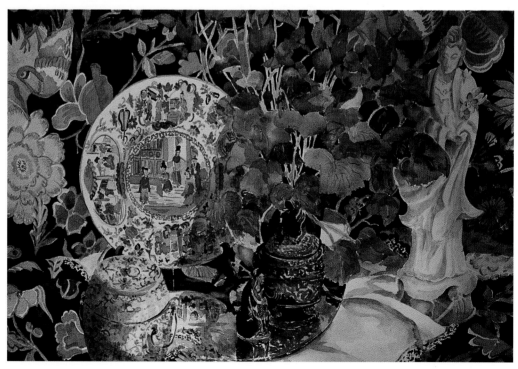

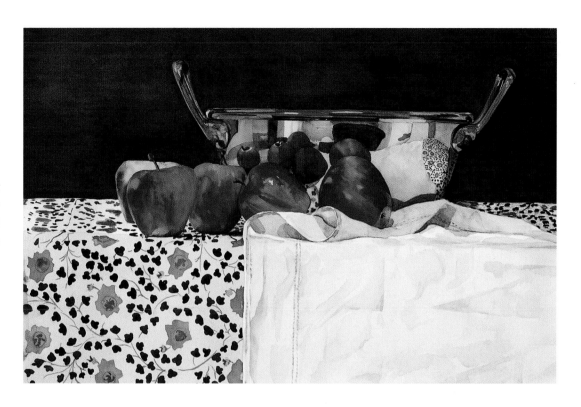

DELL KEATHLEY
Apples and Copper
14" x 19" (36 cm x 48 cm)
Arches 140 lb. cold press

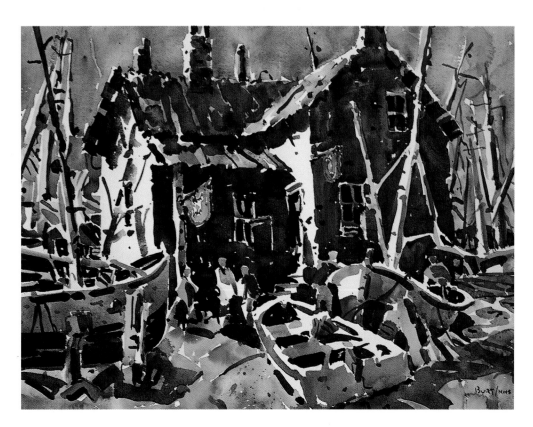

DAN BURT
English Dreamscape
22" x 30" (56 cm x 76 cm)
Arches 300 lb. cold press

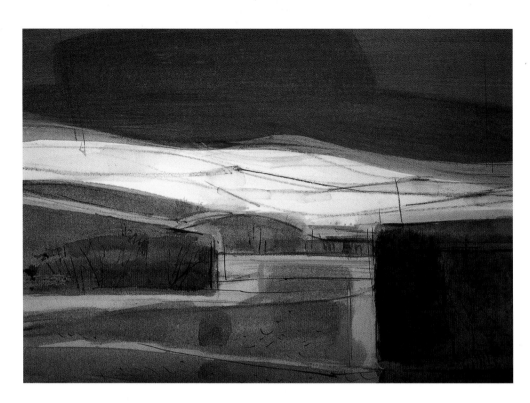

JOHN BARNARD
Oso Flaco
20" x 28" (51 cm x 71 cm)
Strathmore Aquarius II 80 lb. cold press
Watercolor, ink, and pastel

GAYLE DENINGTON-ANDERSON
Metal I: Ben
22" x 30" (56 cm x 76 cm)
Arches 300 lb. rough

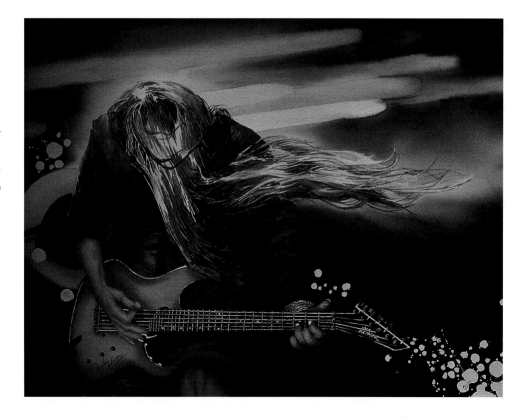

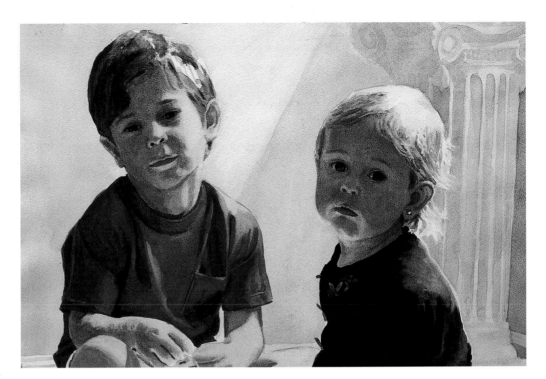

MARGARET CROWLEY-KIGGINS
Saturday Morning
15" x 22" (38 cm x 56 cm)
Lanaquarelle 140 lb. cold press

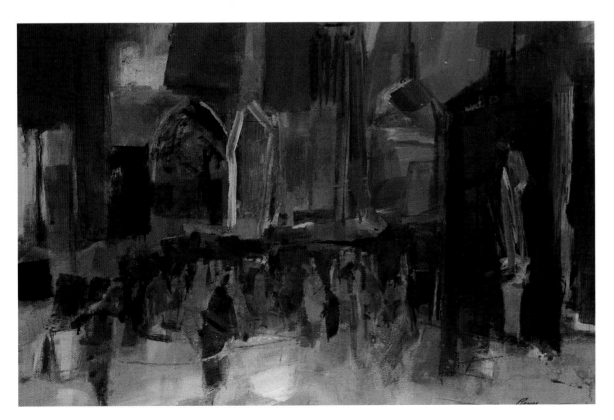

BETTY M. BOWES
Rome
20" x 24" (50 cm x 61 cm)
Masonite
Watercolor and acrylic

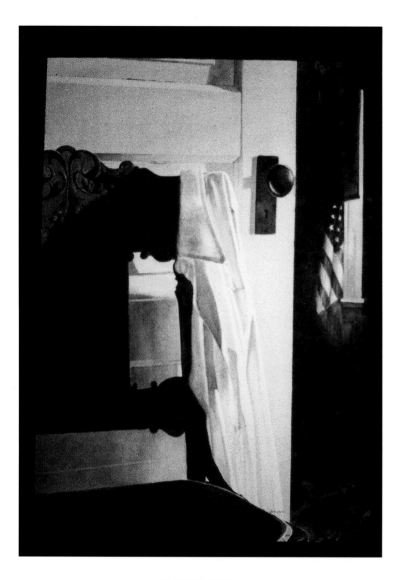

HENRY BELL
Opened to the Morning
28" x 36" (71 cm x 91 cm)
Arches 260 lb. hot press

MARIANNE K. BROWN
Up Tight
30" x 22" (76 cm x 56 cm)
Arches 140 lb. cold press
Special Technique: Textures were made using plastic
wrap, salt, and bubble plastic. Small lines were created
with watercolor and a ruling pen.

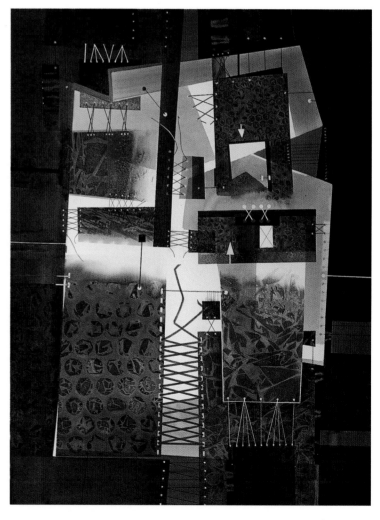

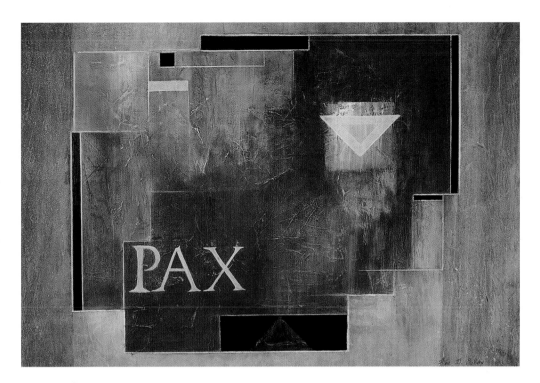

ANNE D. SULLIVAN
Pax I (Connections XVII series)
28" x 36" (71 cm x 91 cm)
Strathmore Aquarius II
Watercolor, acrylic ink, acrylic
paint, and gesso

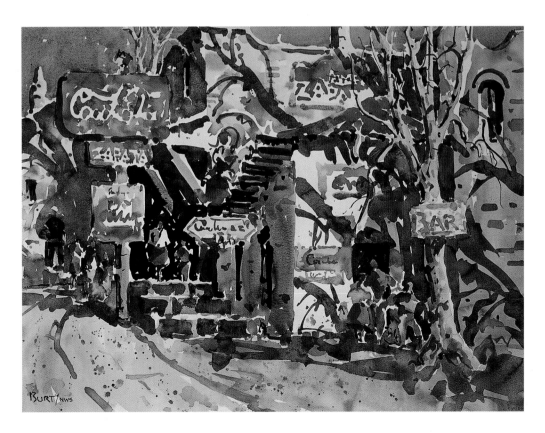

DAN BURT
Signs of the Times
22" x 30" (56 cm x 76 cm)
Arches 140 lb. cold press

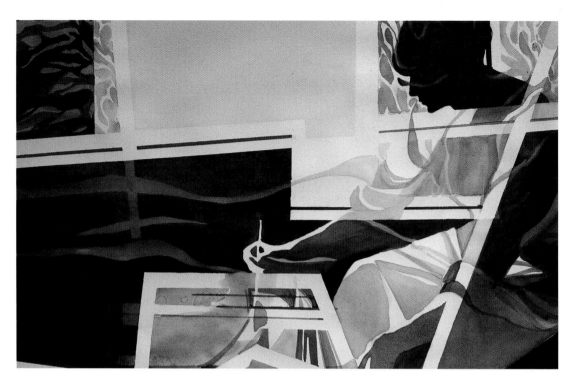

LUCIJA DRAGOVAN
The Work We Choose Should Be Our Own
22" x 30" (56 cm x 76 cm)
Arches 140 lb. cold press

KEN HANSEN
Bags and Oranges
15" x 21" (38 cm x 53 cm)
Arches 300 lb. cold press

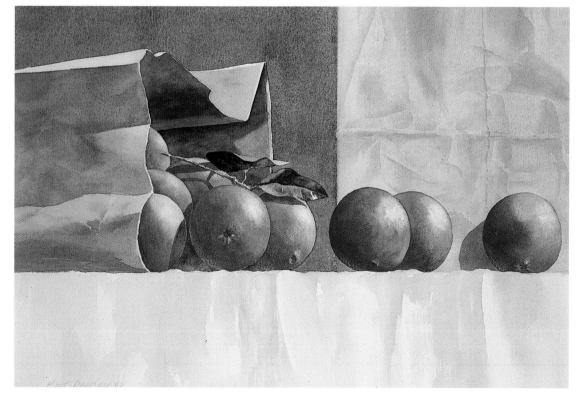

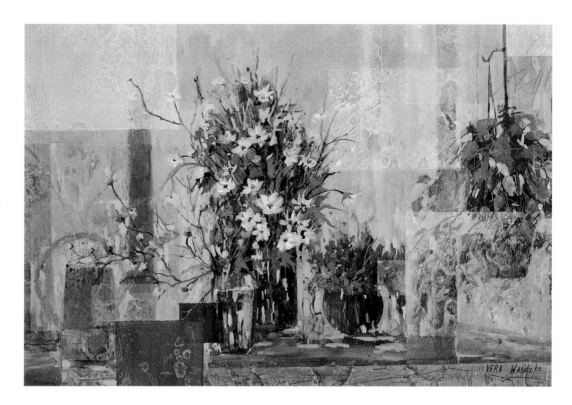

WOLODIMIRA VERA WASICZKO
A Summer Moment
26" x 36" (66 cm x 91 cm)
Crescent 100% rag
Watercolor, acrylic, and gesso

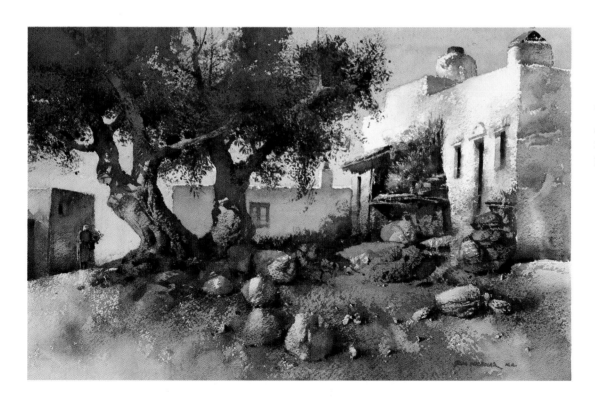

TOM NICHOLAS
Morning Light—Sianna, Greece
12" x 19" (30 cm x 48 cm)
Fabriano 300 lb. cold press

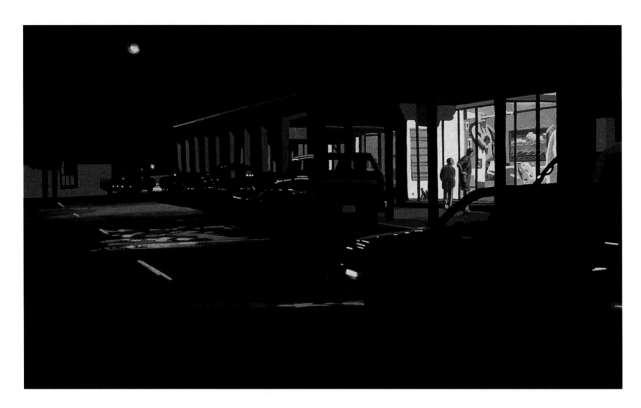

JAMES FARRAH
Window Shopping
15" x 22" (38 cm x 56 cm)
Winsor & Newton 260 lb.
cold press
Watercolor and gouache

ELENA ZOLOTNITSKY
Sepia Dreams
22.5" x 30" (57 cm x 76 cm)
Strathmore

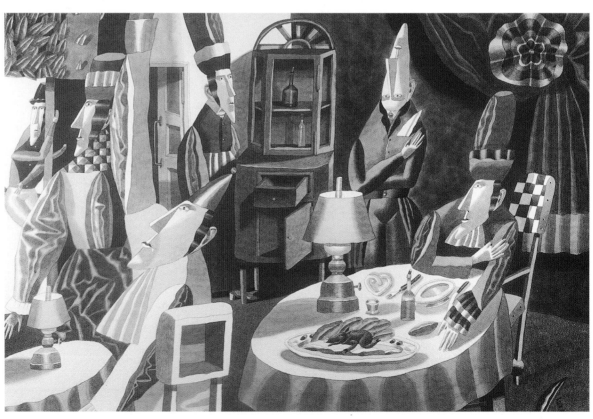

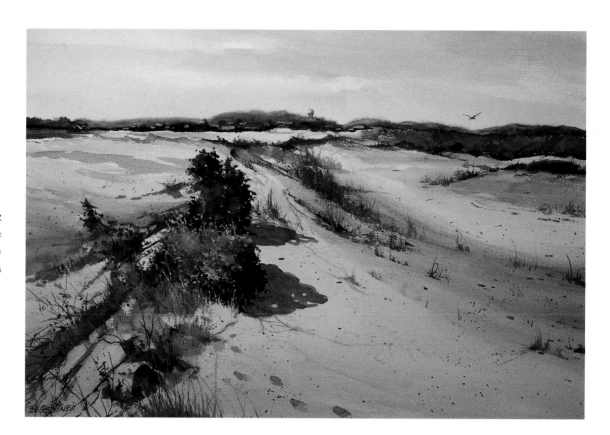

BERNARD GERSTNER
Plum Island Dunes
22" x 29" (56 cm x 74 cm)
Arches 300 lb. cold press

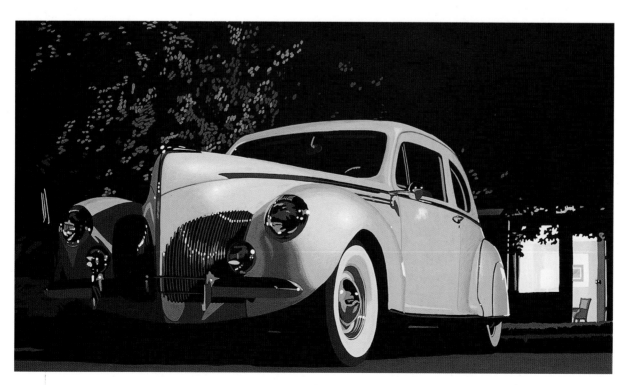

JAMES FARRAH
Rendezvous
15" x 22" (38 cm x 56 cm)
Lanaquarelle 260 lb.
cold press
Watercolor and gouache

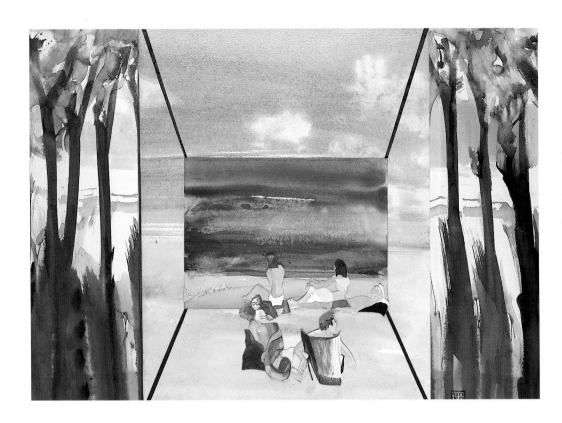

RUTH L. ERLICH
Watercolor: Third Dimension VII
32" x 43" (81 cm x 109 cm)
140 lb. rough
Watercolor and diluted fabric dye

JUDITHE RANDALL
Covenant
20" x 29" (51 cm x 74 cm)
Crescent
Watercolor, acrylic, and ink

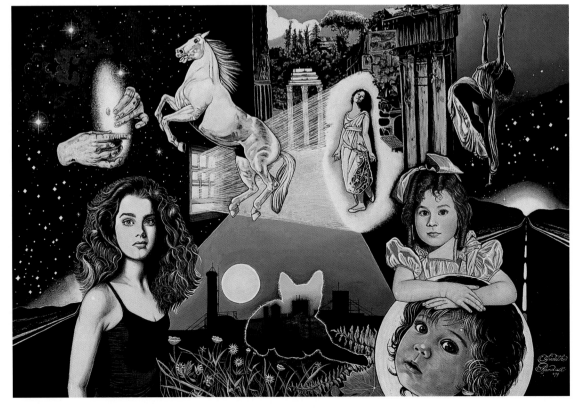

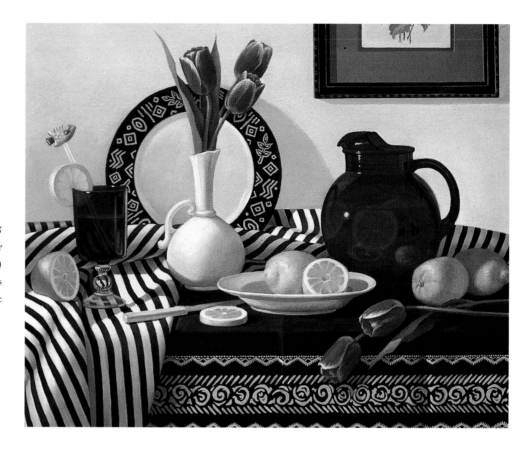

LINDA TOMPKIN
Lemonade
20" x 24" (51 cm x 61 cm)
Strathmore 500 series
Watercolor and acrylic

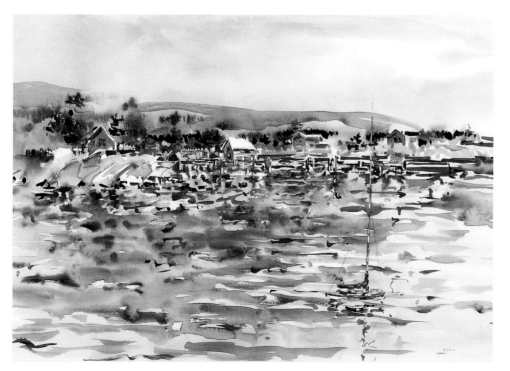

SANDRA THRUBER KUNZ
Harbour Down East
30" x 40" (76 cm x 102 cm)
Rives BFK

83

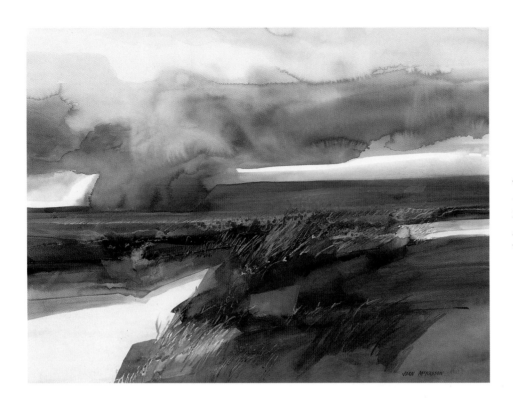

JOAN MCKASSON
Southwest Sunset
22" x 30" (56 cm x 76 cm)
Arches 140 lb. cold press
Watercolor and gouache

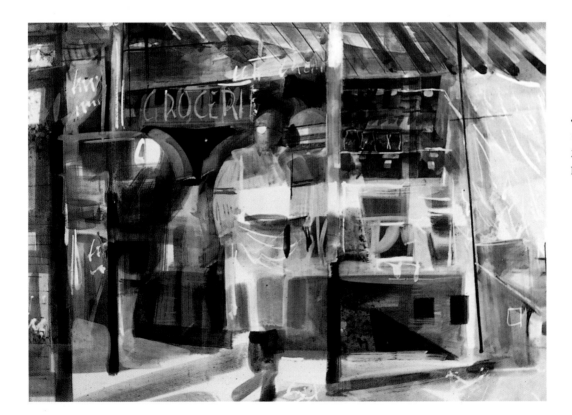

JANE OLIVER
Grocer
25" x 30" (64 cm x 76 cm)
Hot press

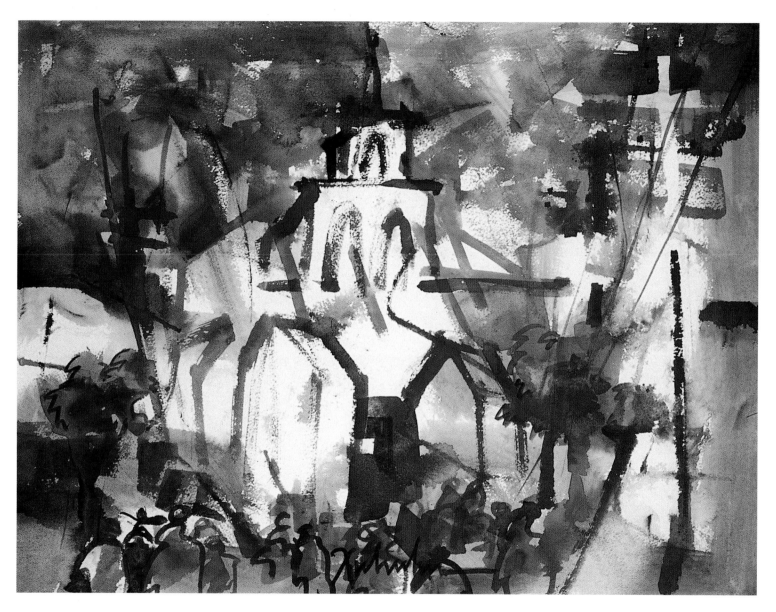

HENRY FUKUHARA

Iglesia San Antonio

18" x 24" (46 cm x 61 cm)

Waterford 140 lb. rough

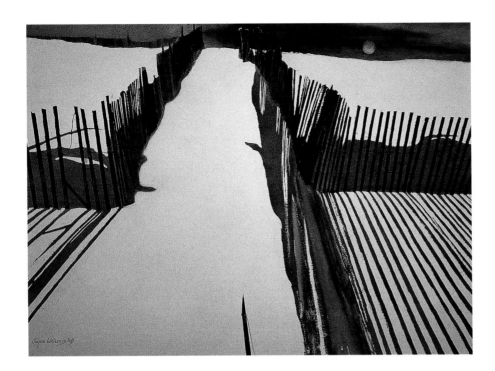

JOYCE WILLIAMS
Winter Moon
22" x 30" (56 cm x 76 cm)
Arches 300 lb. cold press

ANITA MEYNIG
Air Borne
22" x 28" (56 cm x 71 cm)
Arches 140 lb. cold press
Watercolor and gouache

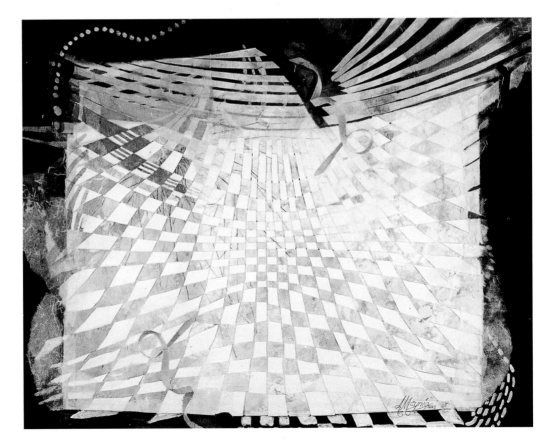

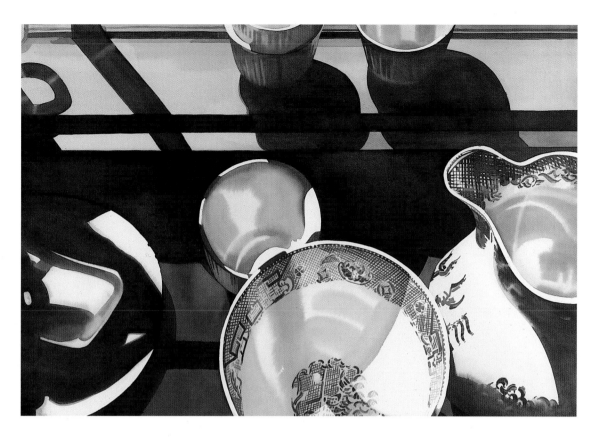

DEBORAH ELLIS
Red Counter White Dishes I
30" x 41" (76 cm x 104 cm)
Arches 555 lb. cold press

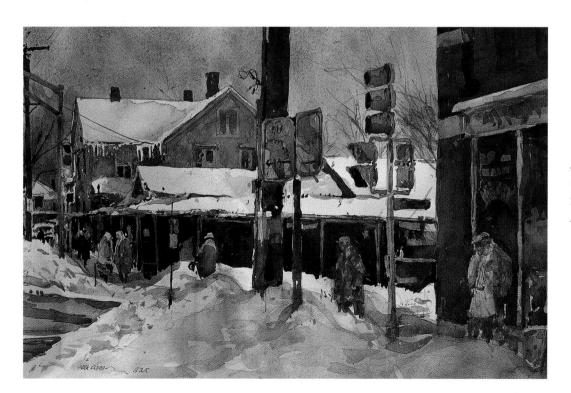

JACK FLYNN
Closed Tyler Market
15" x 22" (38 cm x 56 cm)
Arches 140 lb. cold press

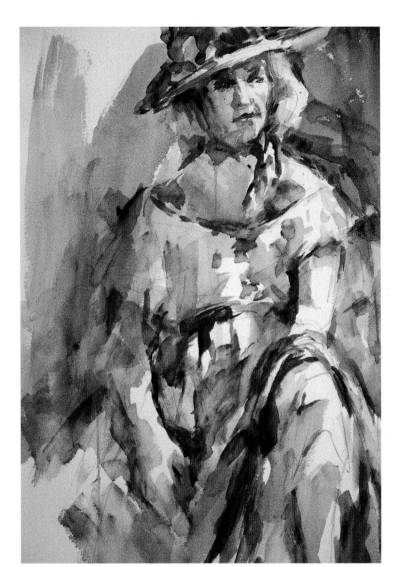

JONATHAN BLATT
The Flowered Hat
13" x 21" (33 cm x 53 cm)
Arches 140 lb. cold press

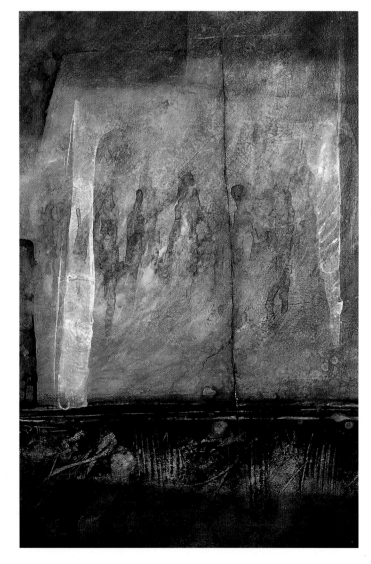

JIM PITTMAN
Shadow People—Wallmark Series
30" x 22" (76 cm x 56 cm)
Strathmore Aquarius
Watercolor, acrylic, watercolor
pencil, and watercolor crayon

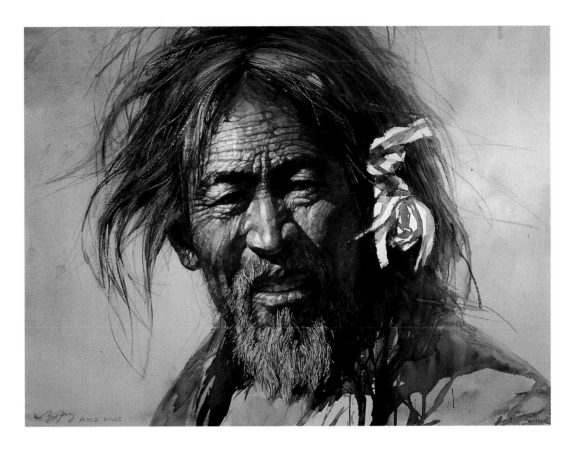

Z. L. Feng
Mountain Man
22" x 30" (56 cm x 76 cm)
Arches 140 lb. cold press

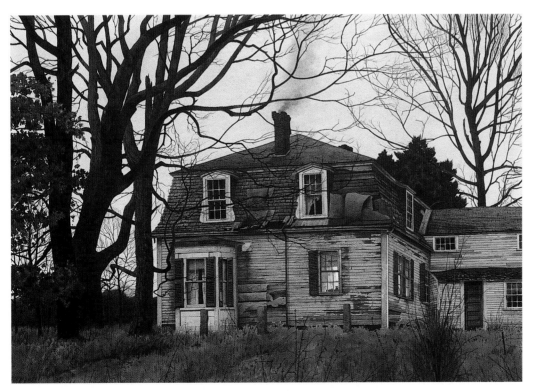

Loring W. Coleman
November Evening
21" x 29" (53 cm x 74 cm)
Waterford 300 lb. cold press

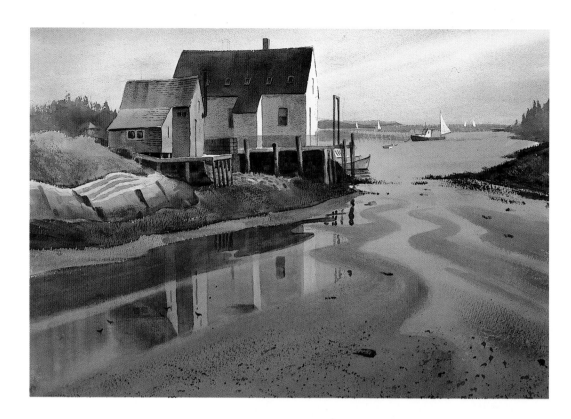

MARTIN R. AHEARN
Ebb Tide—Orr's Island, ME
21" x 29" (53 cm x 74 cm)
300 lb. cold press

JANE DESTRO
Claire
17" x 19" (43 cm x 48 cm)
Fabriano Artistico 140 lb.

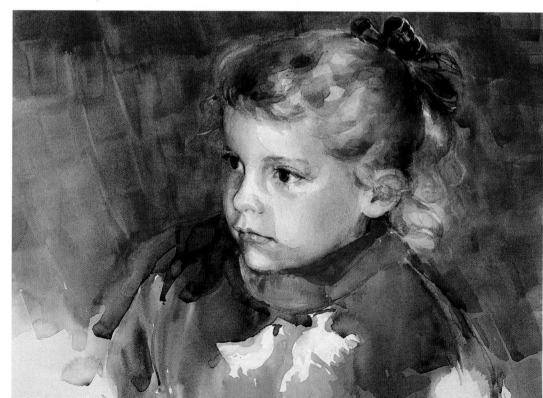

SHERRY LOEHR
Random Play
28" x 20" (71 cm x 51 cm)
Arches 140 lb. hot press
Watercolor and acrylic

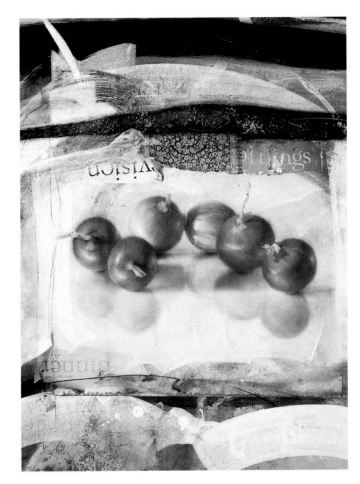

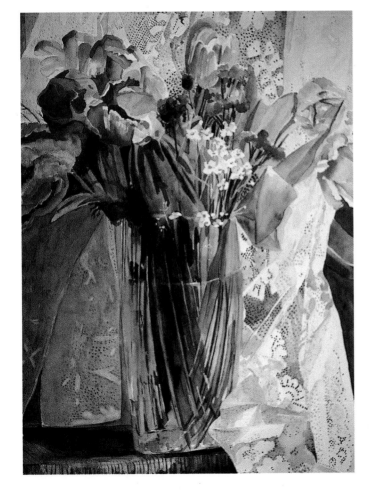

PAT FORTUNATO
Betty's Gift #2
30" x 22" (76 cm x 56 cm)
Waterford 140 lb. cold press

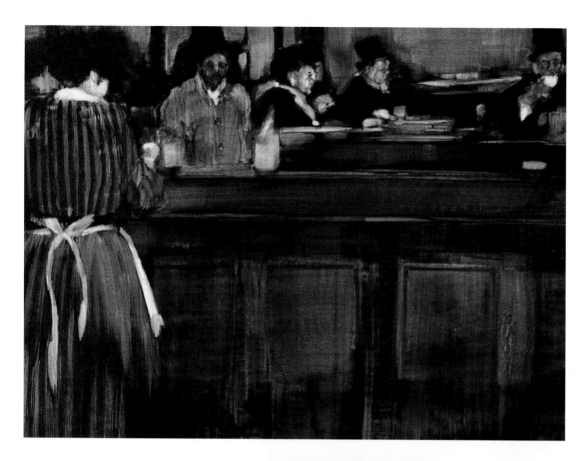

ALFRED CHRISTOPHER
Café Marcel
8" x 11" (20 cm x 28 cm)
Strathmore 500 series 140 lb.

BARBARA SCULLIN
Nature's Harmony
30" x 40" (76 cm x 102 cm)
Arches 300 lb. cold press

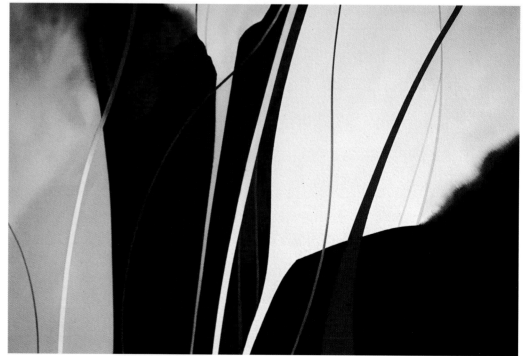

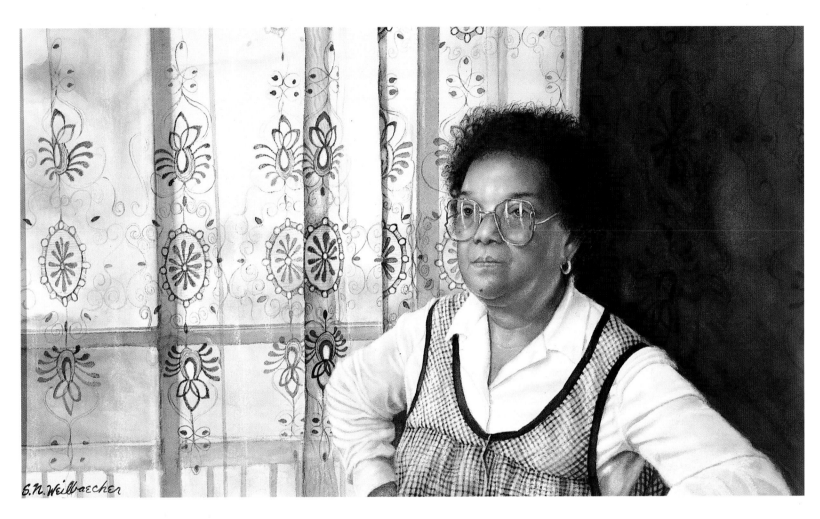

SHARON WEILBAECHER

Thelma and Lace

13.5" x 23" (34 cm x 58 cm)

Arches 300 lb. cold press

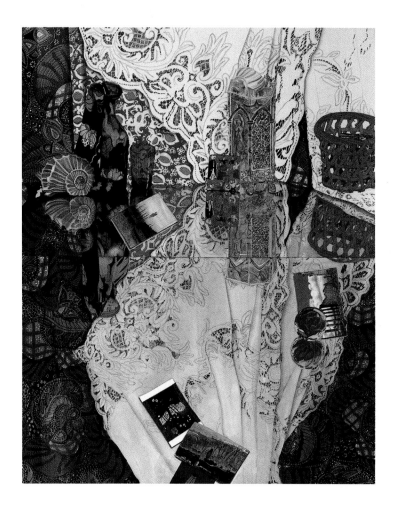

STELLA DOBBINS
Foreign Resonances, VI
50.5" x 40" (128 cm x 102 cm)
Arches 140 lb. cold press

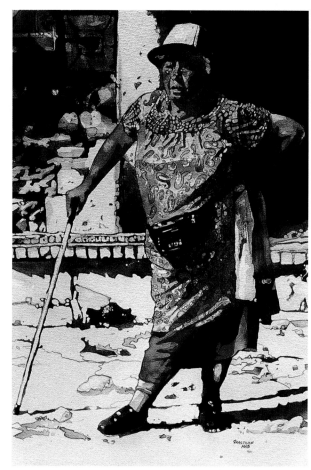

JEAN GRASTORF
Chichen Itza
28" x 20" (71 cm x 51 cm)
Waterford 300 lb. cold press

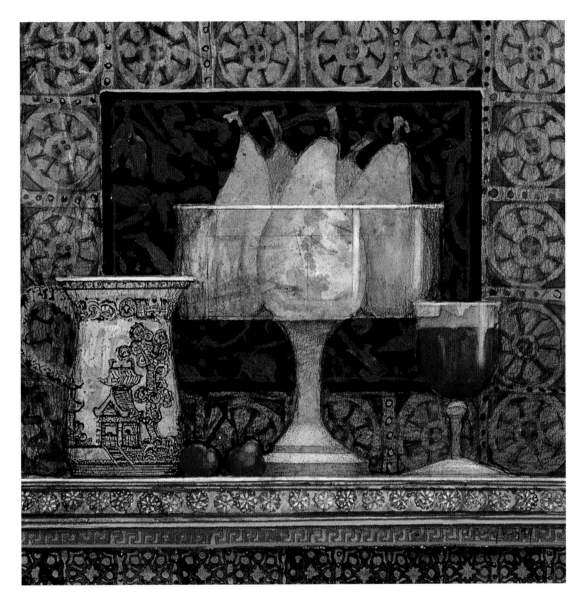

ANNE BAGBY

French Pears

13" x 13" (33 cm x 33 cm)

Watercolor board

Watercolor and acrylic

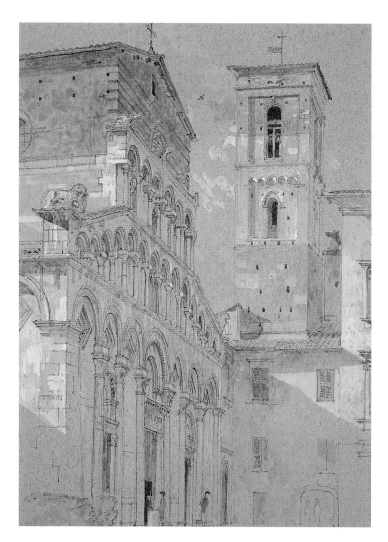

CHARLOTTE HALLIDAY
Santa Maria Forisportam—Lucca
15" x 12" (38 cm x 30 cm)
Ingres 160 gsm
Watercolor and pencil

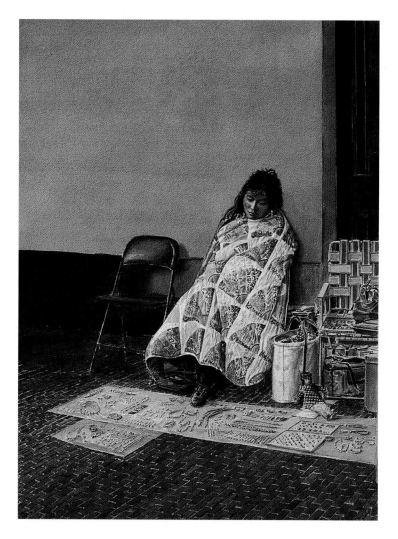

NICK SCALISE
Staying Warm—Vendor, Santa Fe, NM
28" x 22" (71 cm x 56 cm)
140 lb. cold press

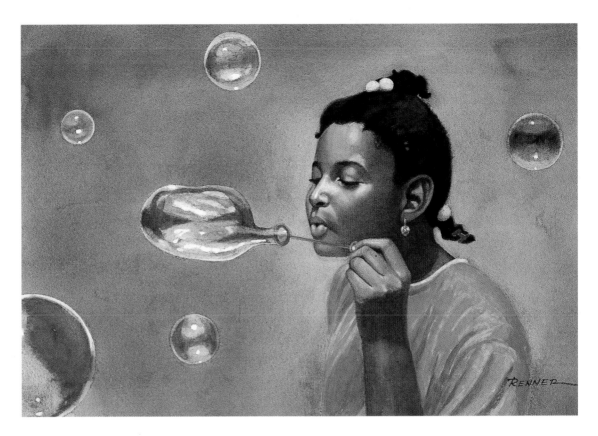

DONALD G. RENNER
Bubbles
13" x 19" (33 cm x 48 cm)
Arches 140 lb. cold press

DAVID S. DeMARCO
In the Waning Hours
20" x 30" (51 cm x 76 cm)
Cold press

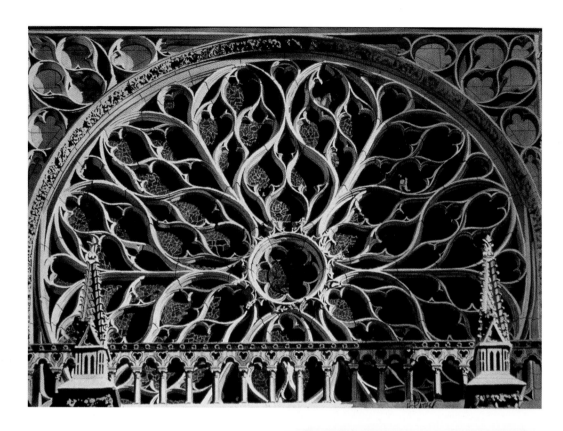

L. HERB RATHER, JR.
Rose Window—Sainte Chapelle
30" x 22" (76 cm x 56 cm)
Arches 140 lb. rough

BRUCE G. JOHNSON
School's Out
21" x 29" (53 cm x 74 cm)
Arches 300 lb. rough

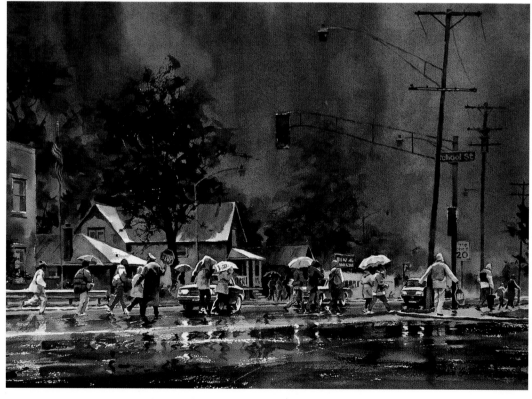

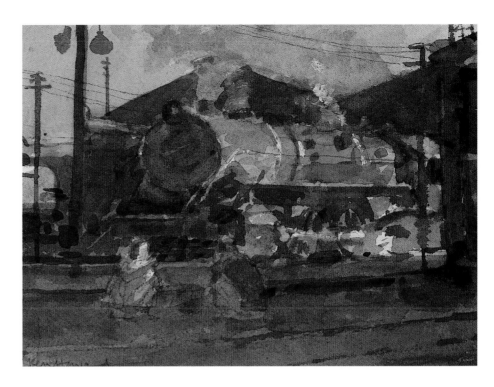

KEN HOWARD

Jhansi Loco—India

5" x 7" (13 cm x 18 cm)

Arches 300 lb. rough

Watercolor and Chinese white

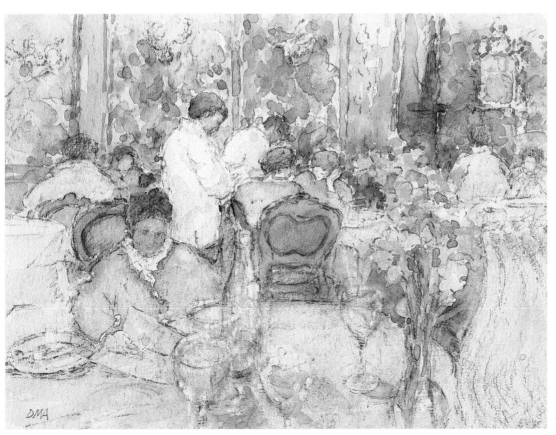

DIANA ARMFIELD

Ristorante Il Giglio—Venice

6" x 8" (15 cm x 20 cm)

Sanderson 140 lb.

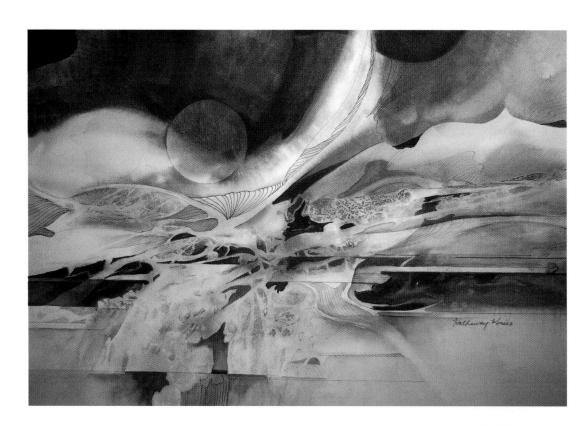

SHIRLEY KRUISE HATHAWAY
Indecisive I
32" x 40" (81 cm x 102 cm)
300 lb. cold press
Watercolor and white opaque ink

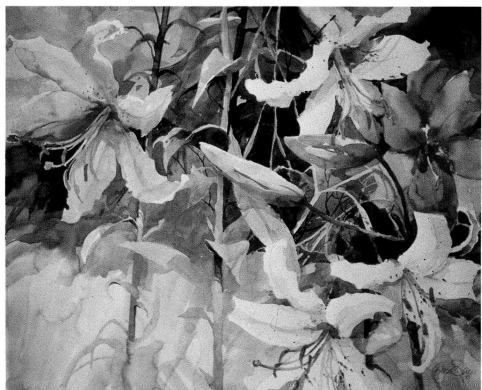

SUSAN SPENCER
Oriental Lilies
28" x 36" (71 cm x 91 cm)
Fabriano 140 lb. hot press

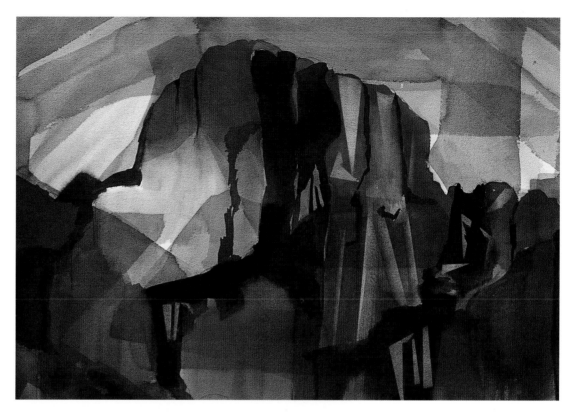

ROWENA FRANCIS
Sugar Loaf
22" x 30" (56 cm x 76 cm)
Arches 300 lb. cold press

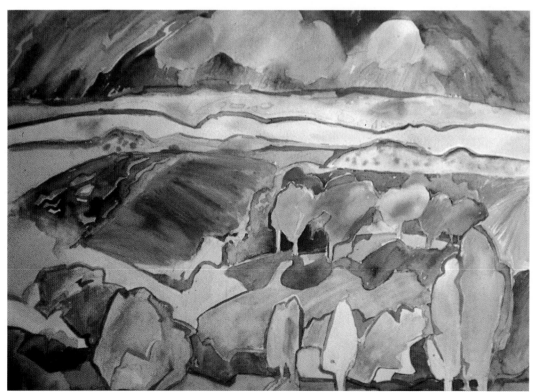

SUSAN AMSTATER SCHWARTZ
Rio Grande Valley
20" x 25" (51 cm x 64 cm)
Arches 140 lb.

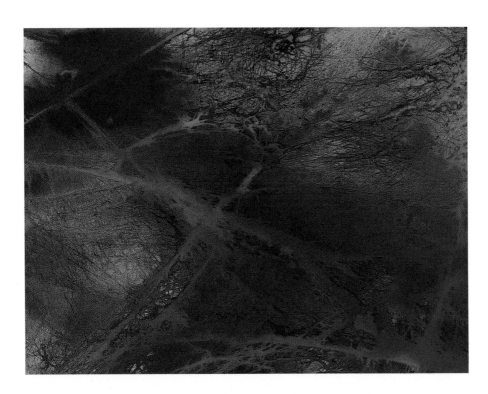

MARY ANN BECKWITH
Sunrise, Sunset
22" x 30" (56 cm x 76 cm)
Arches 140 lb. hot press
Watercolor and ink
Special Technique: Halloween cobwebs are stretched over the paper, water is then poured over the surface, and diluted W.C.I. is sprayed onto the surface.

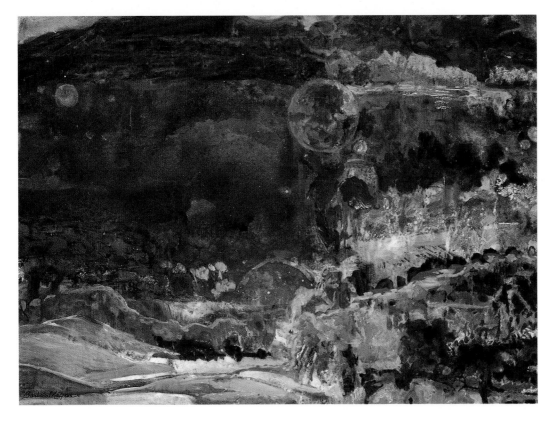

BARBARA KEYSER
Santa Fe II
22" x 17" (56 cm x 43 cm)
Arches 140 lb. cold press
Watercolor and acrylic

H. C. Dodd
One Half Three
30" x 22" (76 cm x 56 cm)
300 lb. cold press

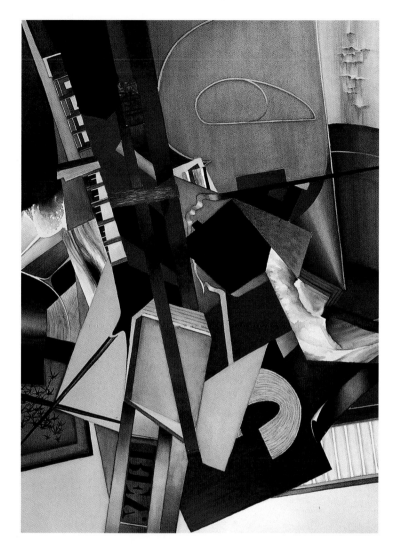

Christine Fortner
Hot Tomatoes
13" x 21" (33 cm x 53 cm)
Arches 140 lb. cold press

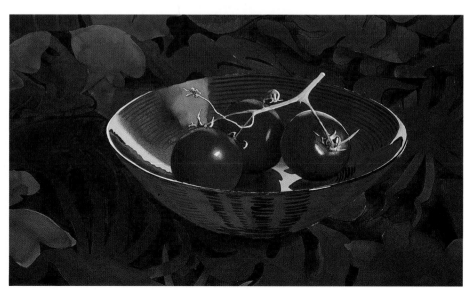

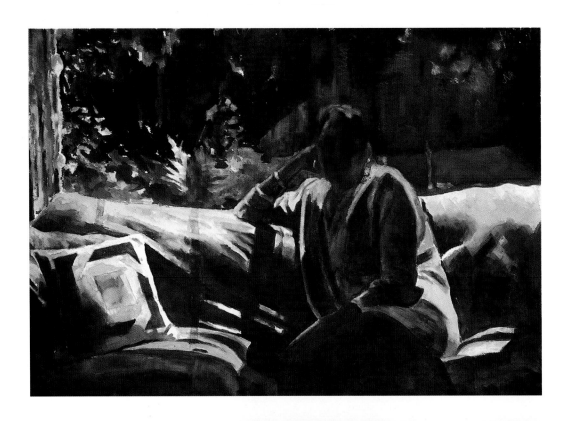

PAT BERGER

The End of the Day
29" x 36" (74 cm x 91 cm)
Arches 300 lb. cold press
Watercolor and pastel

RALPH BUSH

Northern Exposure
20" x 25" (51 cm x 64 cm)
Strathmore 500 series 140 lb.
Watercolor and white gouache

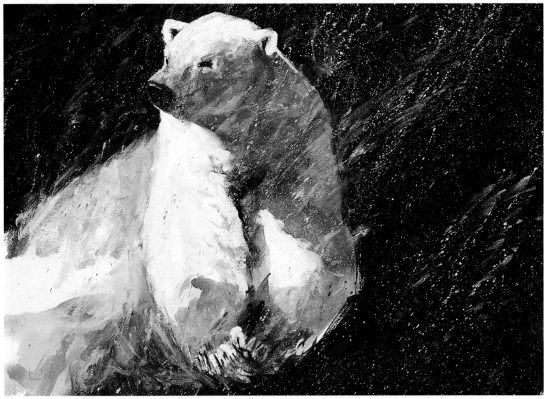

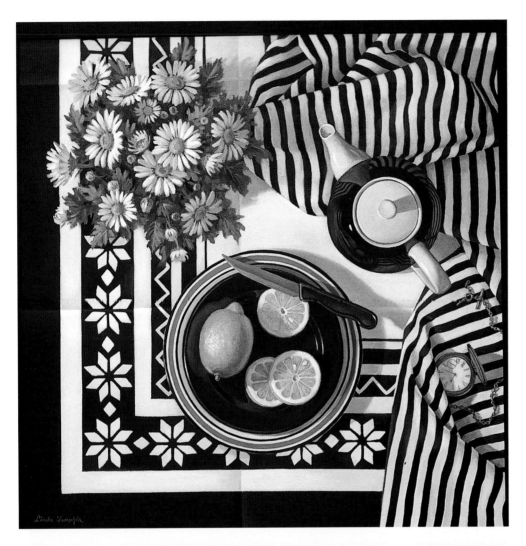

LINDA TOMPKIN
Lemon Delight
22" x 22" (56 cm x 56 cm)
Strathmore 500 series
Watercolor and acrylic

CARRIE BURNS BROWN
Wrappings
12" x 22" (30 cm x 56 cm)
100% rag mat board
Watercolor, acrylic, ink stained silk,
and collage

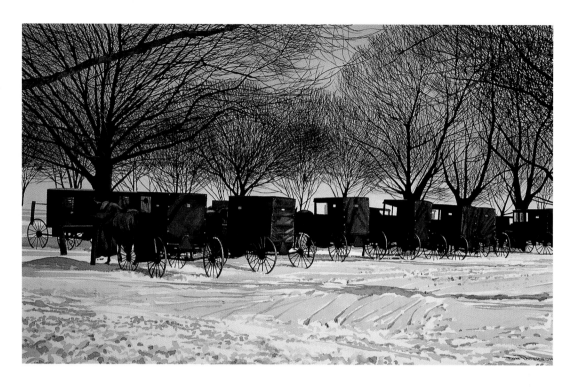

DONALD W. PATTERSON
The Sabbath
16" x 28" (41 cm x 71 cm)
300 lb. cold press

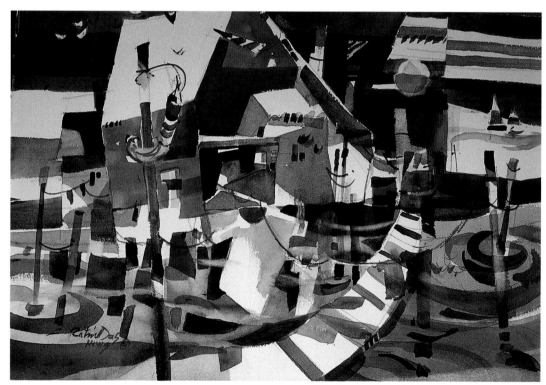

RATINDRA DAS
Fun by the Bay
15" x 22" (38 cm x 56 cm)
Arches 140 lb. cold press

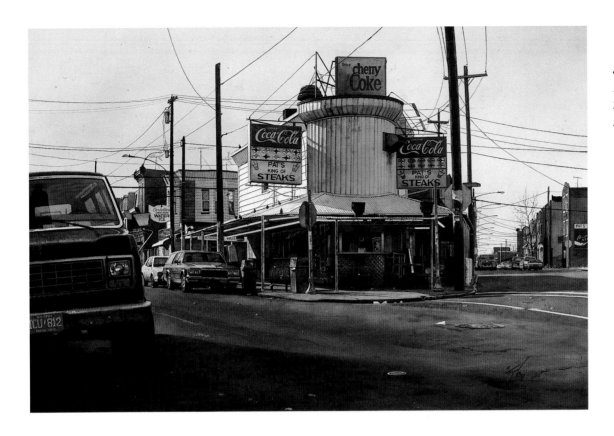

JAMES TOOGOOD
Pat's
21" x 29.5" (53 cm x 74 cm)
Arches 140 lb. cold press

MARTIN R. AHEARN
Island Man
21" x 29" (53 cm x 74 cm)
300 lb. cold press

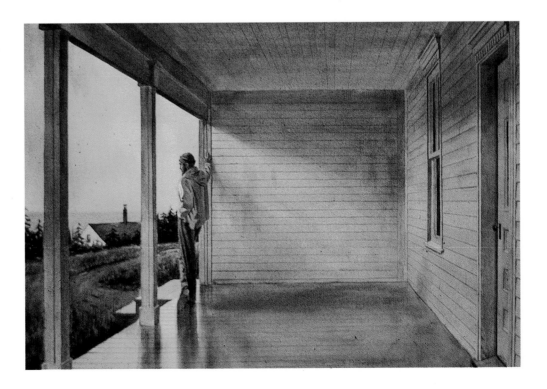

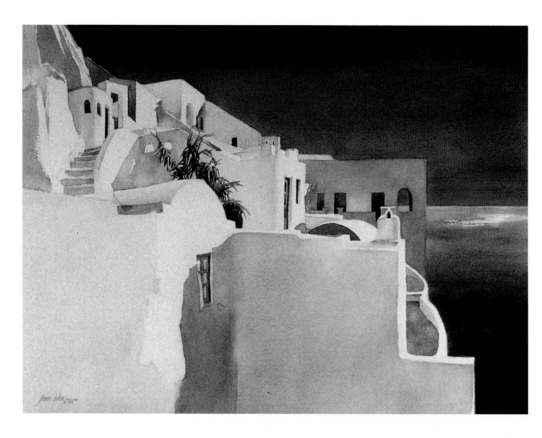

JEANNE DOBIE
Aegean Shadows
22" x 30" (56 cm x 76 cm)
Arches 140 lb. cold press

KAY REBBER FOOTE
Fishin'
22" x 29.5" (56 cm x 75 cm)
Fabriano 300 lb. cold press

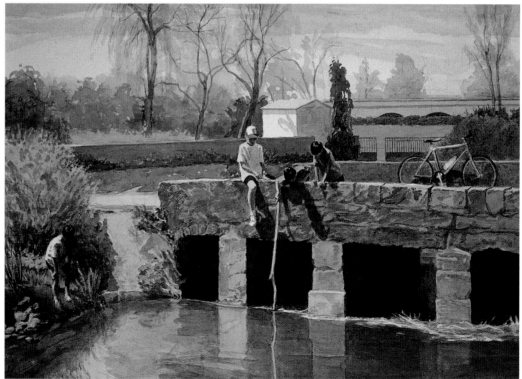

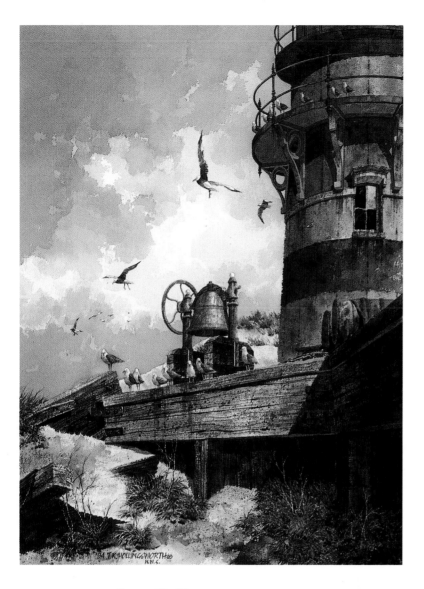

JOHN R. HOLLINGSWORTH

Tenants in Common
29" x 21" (74 cm x 53 cm)
300 lb. rough
Special Technique: White lines scraped with
razor, no white paint used.

JIM BROWER

Unexpected Downpour
29.5" x 19.5" (75 cm x 50 cm)
300 lb. cold press

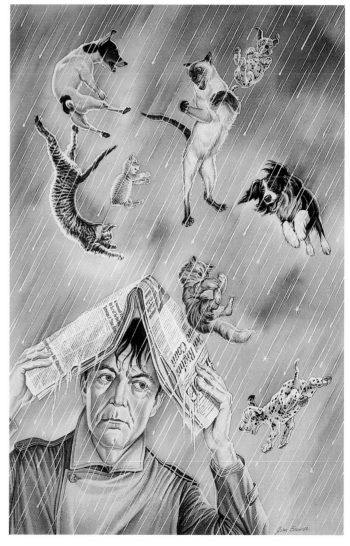

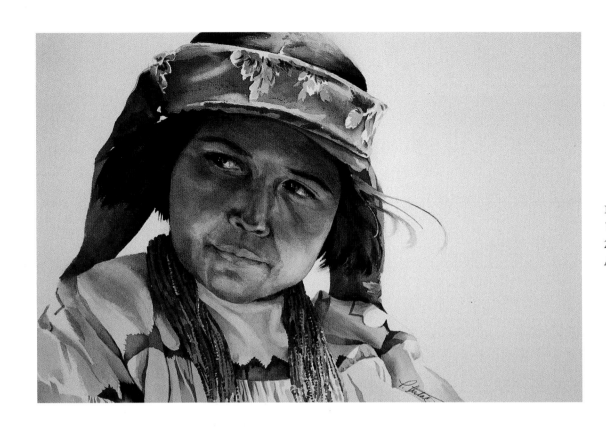

PAULA K. ARTAC
Wolf Eyes
28" x 32" (71 cm x 61 cm)
Arches 300 lb. rough

PAUL STRISIK
Ebb Tide
20" x 28" (51 cm x 71 cm)
Green's 300 lb. rough

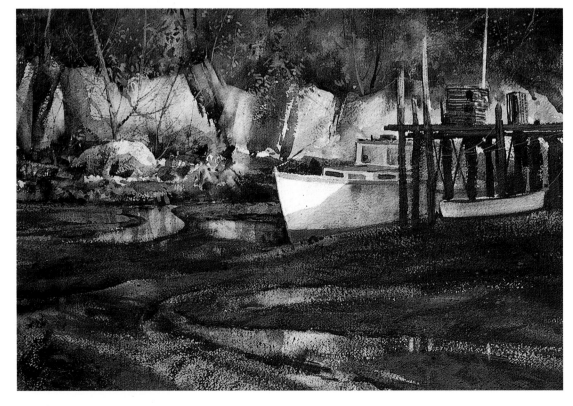

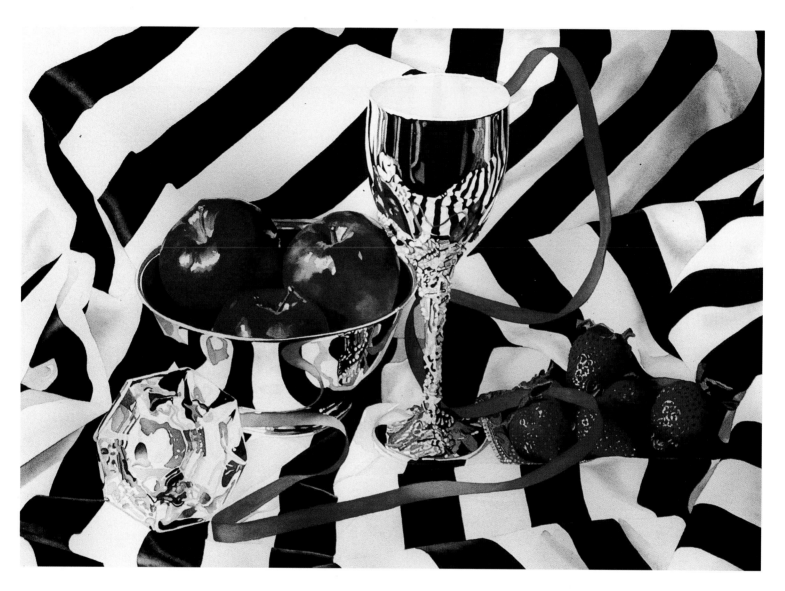

TERRY O'MALEY
Red Ribbon
29.5" x 35.5" (75 cm x 90 cm)
Arches 300 lb. cold press

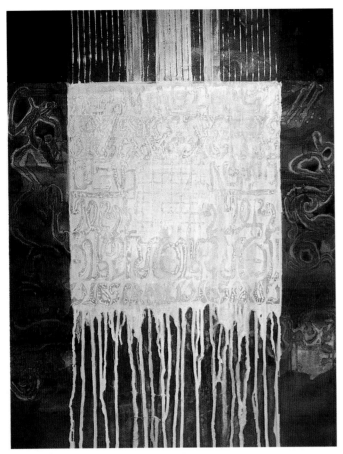

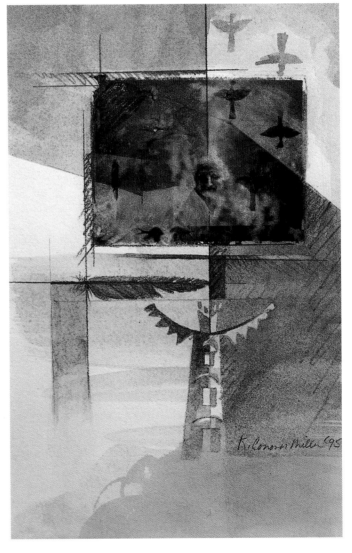

DELDA SKINNER
Dialogue with the Tabernacle
26" x 20" (66 cm x 51 cm)
Arches 300 lb. hot press
Watercolor casein and acrylic

KATHLEEN CONOVER
Contemplation of Flight
8" x 10" (20 cm x 25 cm)
Arches 140 lb. hot press
Watercolor and water-soluble
colored pencils
Special Technique: Polaroid photo images
were transferred from slides directly onto
the watercolor paper.

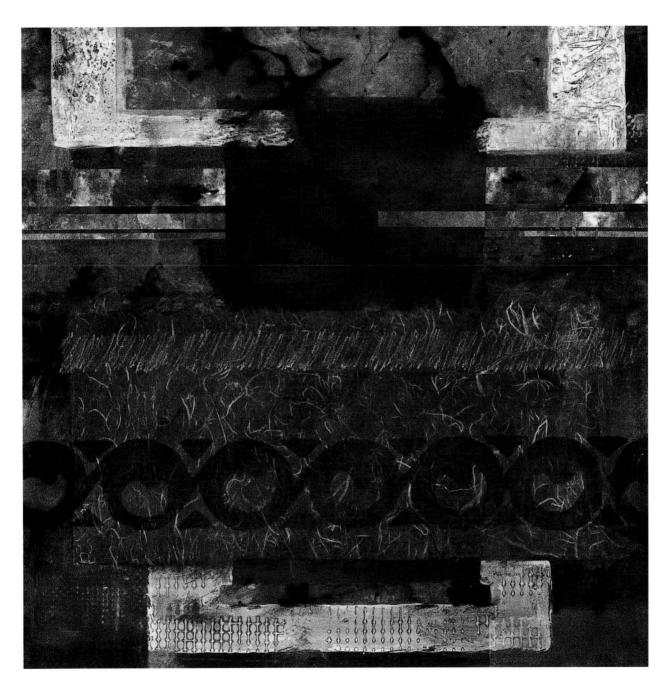

GERRIE L. BROWN
Southwest Images
30" x 30" (76 cm x 76 cm)
Strathmore Aquarius II 80 lb.
Watercolor, acrylics, watercolor crayon, watermedia inks, and collage

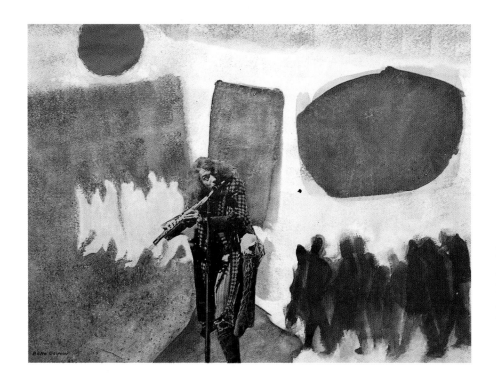

BELLE OSIPOW
Pied Piper (Modern Style)
17.5" x 23.5" (44 cm x 60 cm)
Arches 140 lb.
Watercolor, acrylic, and collage

JOHNNIE CROSBY
Petroglyph Wall—Canyon de Chelle
27" x 34" (69 cm x 86 cm)
Arches 140 lb.

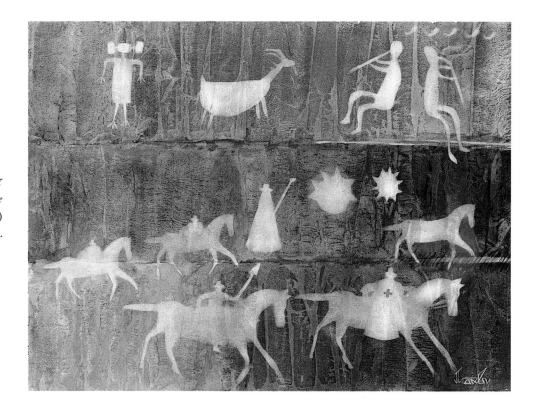

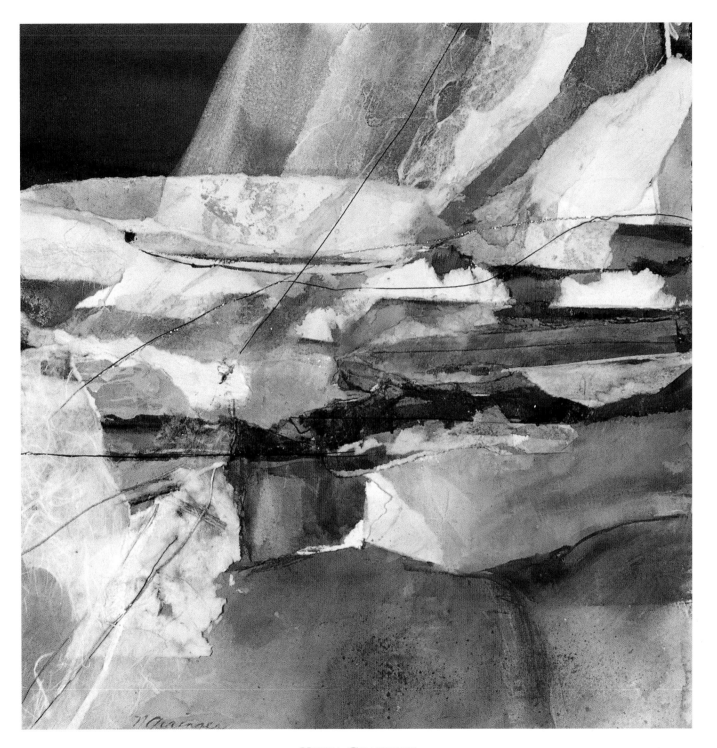

NESSA GRAINGER
Lightshaft
15" x 14" (38 cm x 36 cm)
Arches 140 lb. cold press

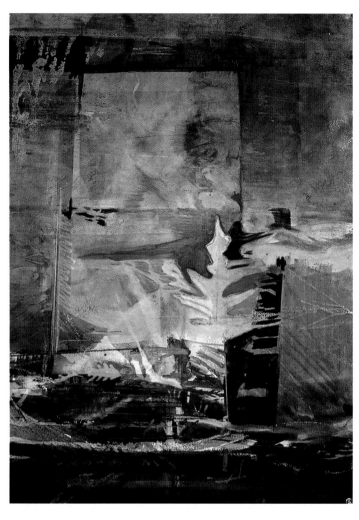

LYNNE KROLL
An Early Frost
36" x 28" (91 cm x 71 cm)
Arches 140 lb. cold press
Watercolor, wax crayon, water-soluble
Craypas, gouache, golden liquid acrylic,
and watercolor pencils

BARBARA BURWEN
Notes
30" x 22" (76 cm x 56 cm)
140 lb. hot press
Watercolor, acrylic, ink, and charcoal powder

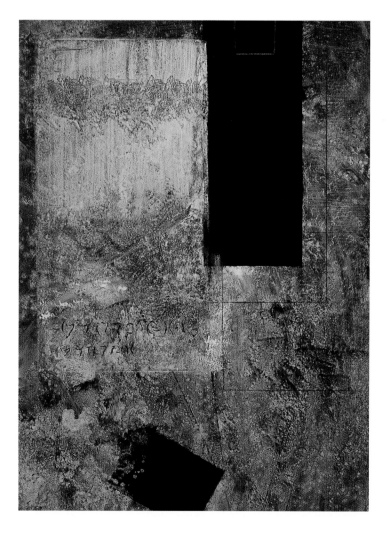

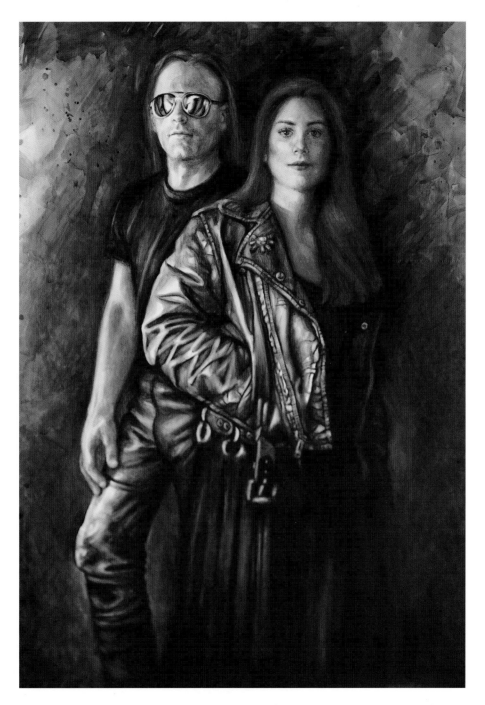

JANE BREGOLI

Crepuscule in Black and Brown: Wendy and Chris

40" x 28" (102 cm x 71 cm)

Strathmore 4-ply bristol

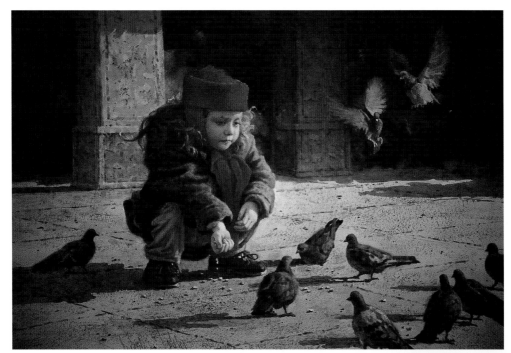

JOSEPH BOHLER
Morning Sunshine—Piazza San Marco
21.5" x 29.5" (55 cm x 75 cm)
Arches 300 lb. cold press

RUTH WYNN
Melissa's Menagerie
28" x 22" (71 cm x 56 cm)
Strathmore plate finish
Special Technique: Doll's face was
patted with cloth while damp to give
smooth appearance.

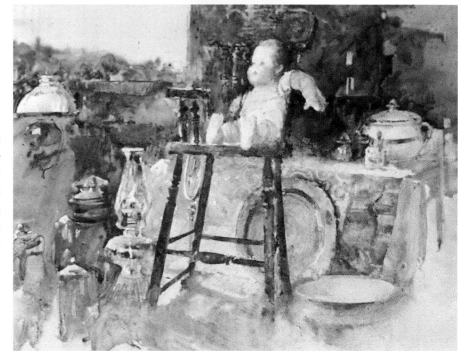

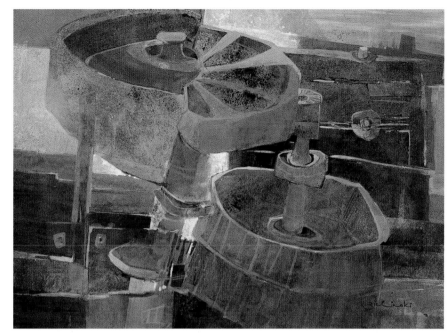

ANN ZEILINSKI
Azurite Patina
22" x 30" (56 cm x 76 cm)
Strathmore Aquarius II 80 lb.
Watercolor and acrylic

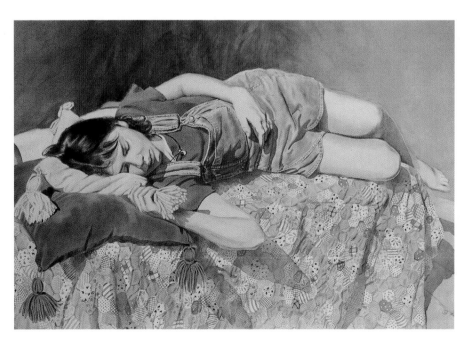

JEAN KALIN
Summertime
17.5" x 28" (44 cm x 71 cm)
Arches 140 lb. cold press

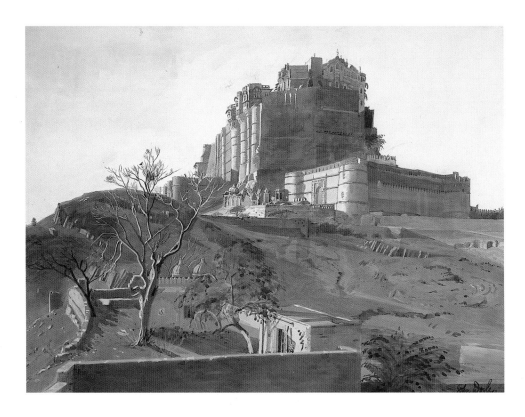

JOHN DOYLE
The Fort—Jodhpur, India
18" x 24" (46 cm x 61 cm)
Ingres Zirkall
Watercolor and gouache

BARBARA GEORGE CAIN
After the Rain
22" x 30" (56 cm x 76 cm)
Arches 140 lb. cold press

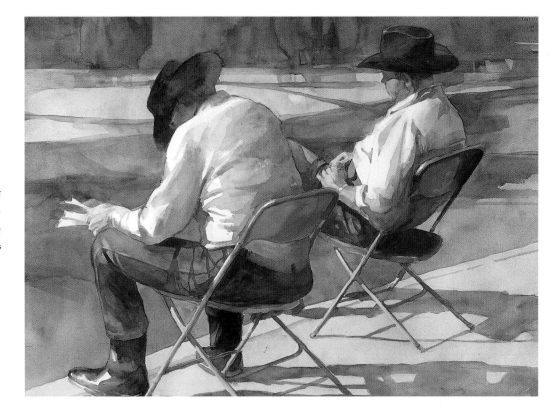

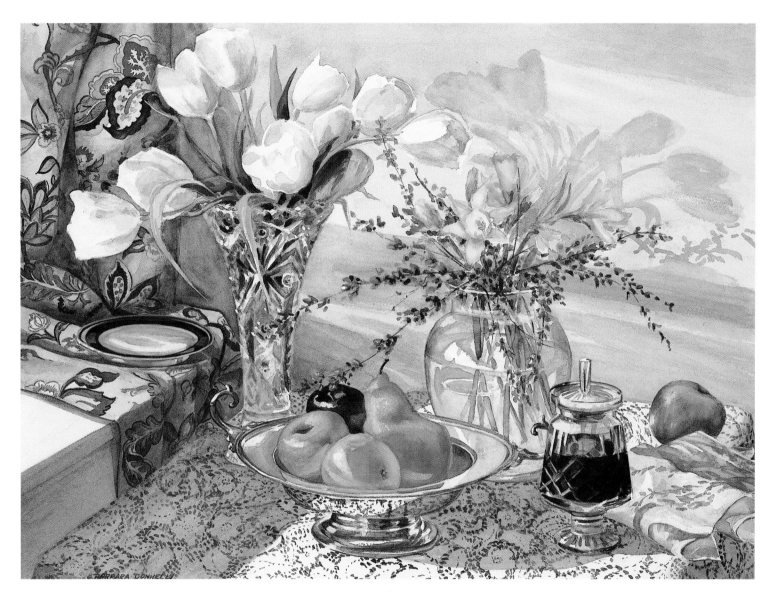

BARBARA DONNELLY

Promise of Spring

22" x 30" (56 cm x 76 cm)

Arches 300 lb. cold press

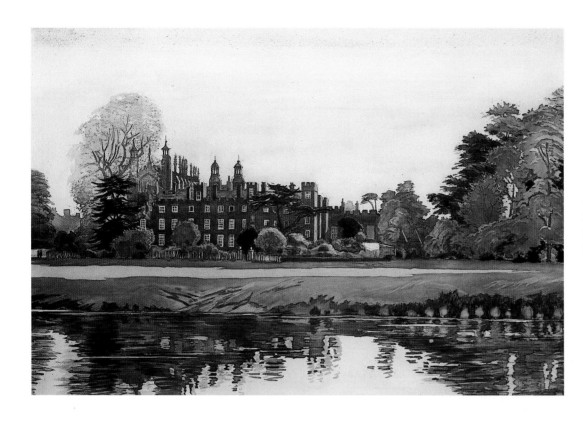

JOHN DOYLE
Eton College—Windsor
18" x 12" (46 cm x 30 cm)
Ingres Zirkall

MURRAY WENTWORTH
August Mist
22" x 30" (56 cm x 76 cm)
Waterford 300 lb. cold press
Watercolor and gouache

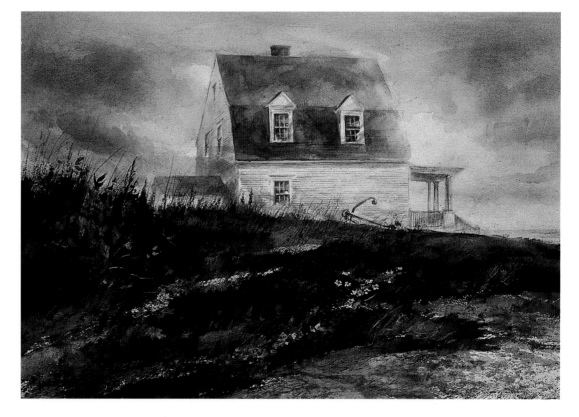

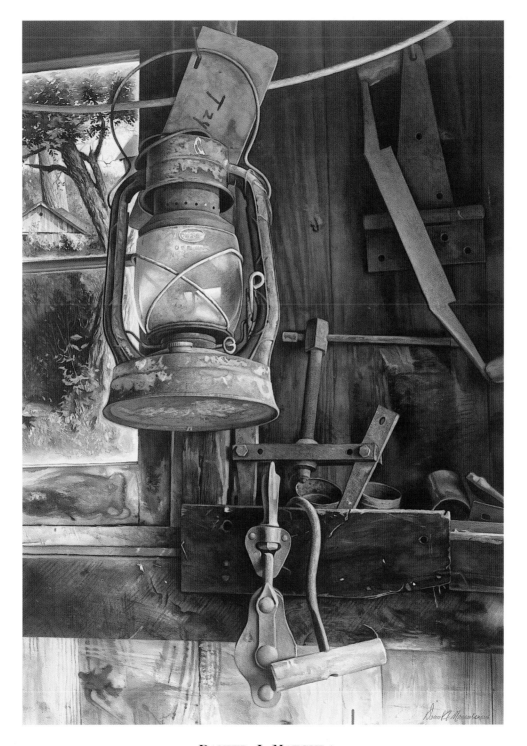

DANIEL J. MARSULA

Lantern II

28" x 20" (71 cm x 51 cm)

Arches 140 lb. cold press

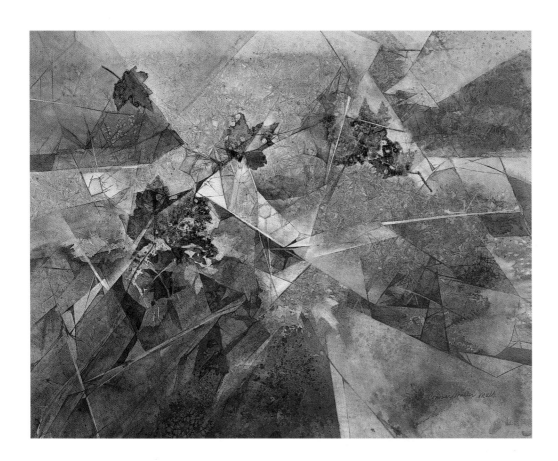

KATHLEEN CONOVER
Winter Fragments
22" x 30" (56 cm x 76 cm)
Arches 140 lb. hot press
Special Technique: Water, liquefied watercolor,
and paper were exposed to outdoor temperatures
of 10°–20°F, producing fragile crystal patterns
and lacy frost textures that were painted,
printed, and stenciled to develop the
composition.

MORRIS SHUBIN
One-Way Downtown
30" x 40" (76 cm x 102 cm)
Crescent 112 lb. rough

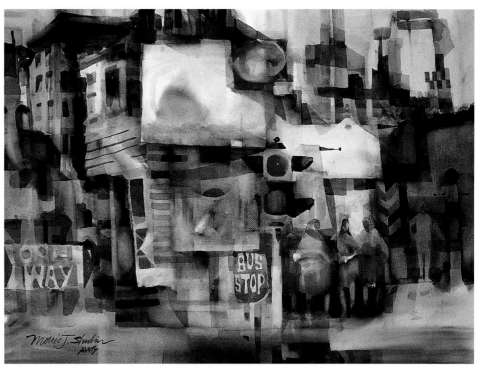

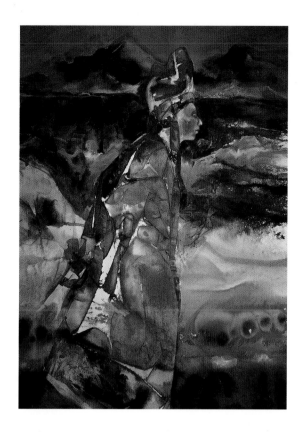

PAT REGAN
Katmandu
30" x 22" (76 cm x 56 cm)
140 lb. cold press

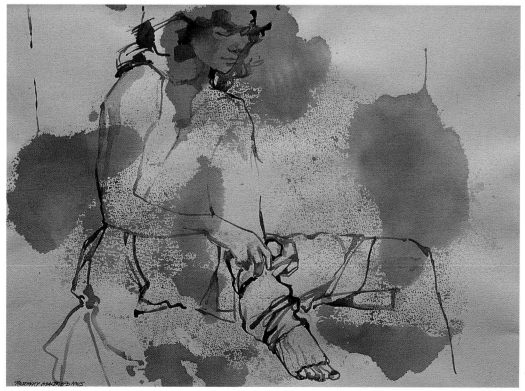

ROSEMARY MACBIRD
Dancer's Leg Warmer
22" x 30" (56 cm x 76 cm)
Arches 140 lb. rough

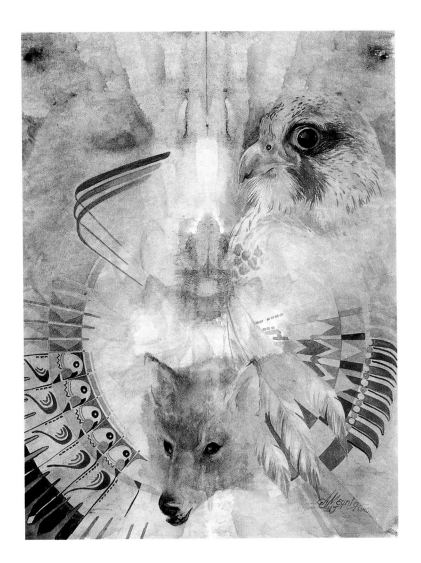

ANITA MEYNIG
Hunter/Hunted
30" x 22" (76 cm x 56 cm)
Arches 140 lb. cold press

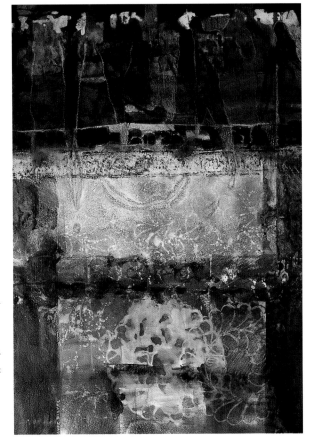

DONNE F. BITNER
Watershed Reliquary
30" x 22" (76 cm x 56 cm)
Strathmore Aquarius II 90 lb. cold press
Watercolor crayon and acrylic

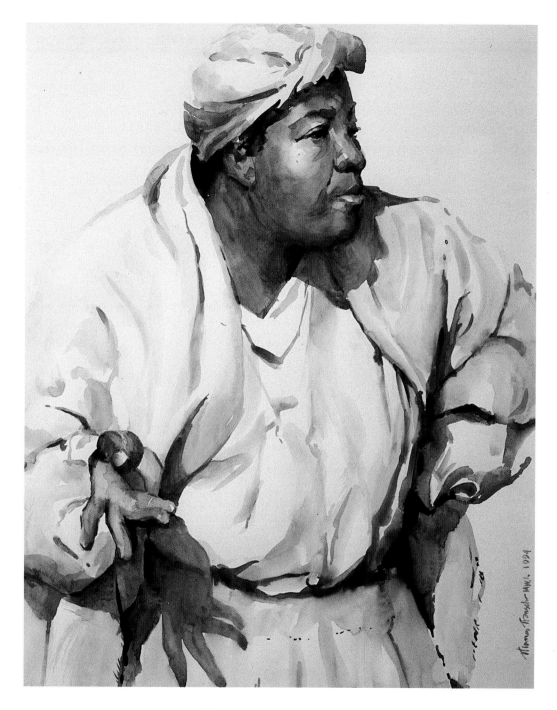

THOMAS V. TRAUSCH

Storyteller

28" x 17" (71 cm x 43 cm)

Arches 140 lb. cold press

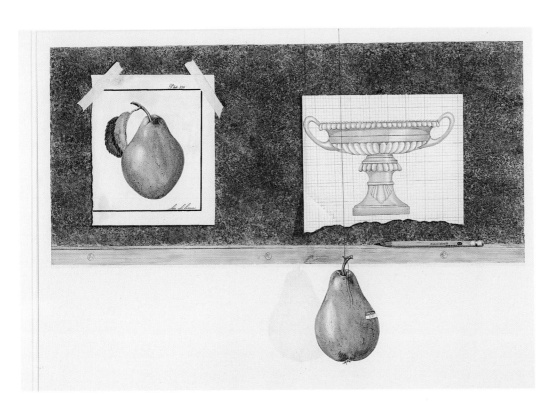

MARI M. CONNEEN
i.e., Still Life
19" x 26" (48 cm x 66 cm)
Strathmore 500 series

DOROTHY WATKEYS-BARBERIS
White Patterns
21" x 29" (53 cm x 74 cm)
Arches 140 lb. medium texture

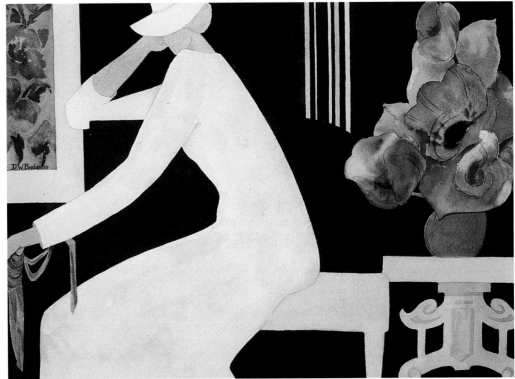

E. GORDON WEST
Inner Landscape
30" x 22" (76 cm x 56 cm)
Arches 300 lb. cold press

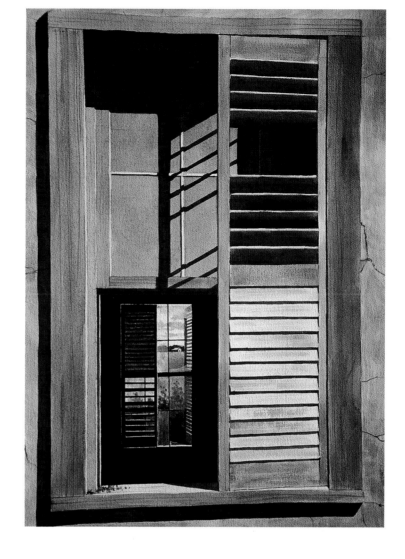

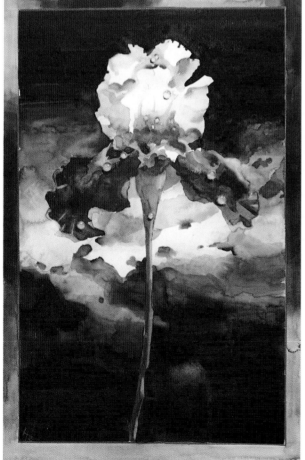

SHARON HILDEBRAND
The Iris Picture
34" x 24" (86 cm x 61 cm)
Fabriano 280 lb. cold press

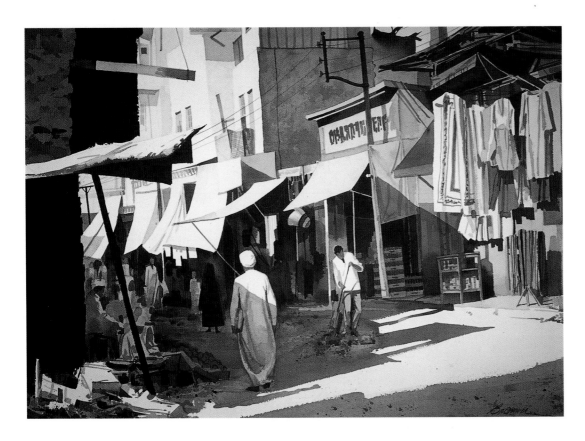

JACK R. BROUWER
Egyptian Market
24" x 29" (61 cm x 74 cm)
Arches 300 lb. cold press

RICHARD SULEA
Coop, South Face
30" x 40" (76 cm x 102 cm)
300 lb. cold press

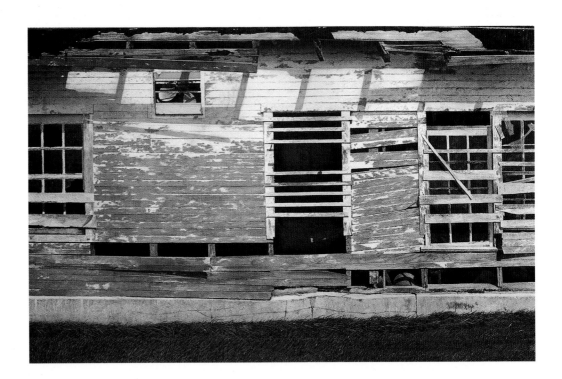

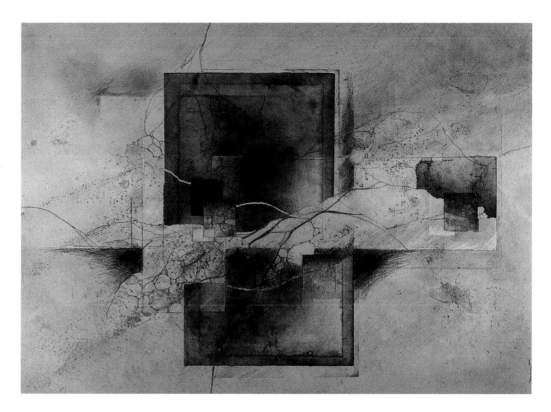

PEGGY BROWN
Crosscurrents
36" x 26" (91 cm x 66 cm)
Rives heavyweight
Watercolor, charcoal, and graphite

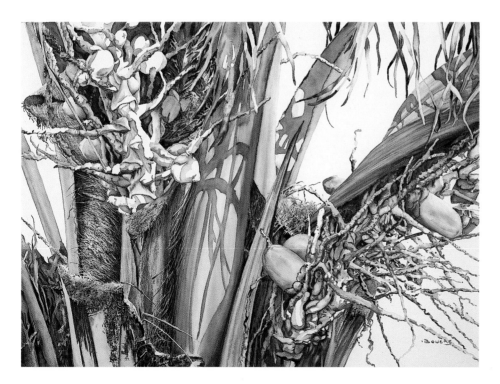

JUNE Y. BOWERS
We're Nuts, of Course
29.5" x 41" (75 cm x 104 cm)
Arches 555 lb. cold press

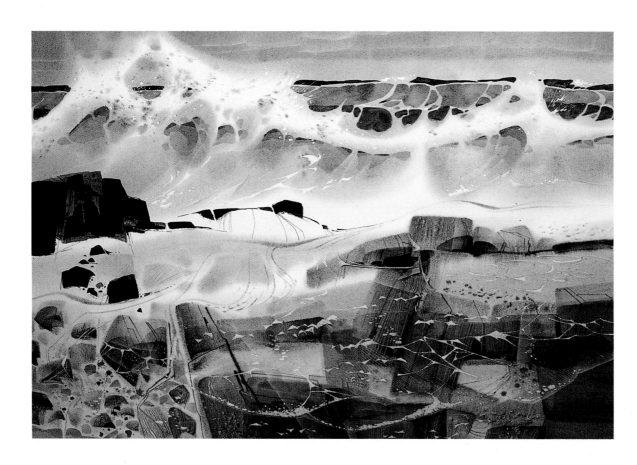

ROBERT ERIC MOORE
Surf-Covered Ledges
29" x 28.5" (74 cm x 72 cm)
Arches 140 lb. cold press

JERRY H. BROWN
Bobbie
22" x 30" (56 cm x 76 cm)
Arches 300 lb. cold press

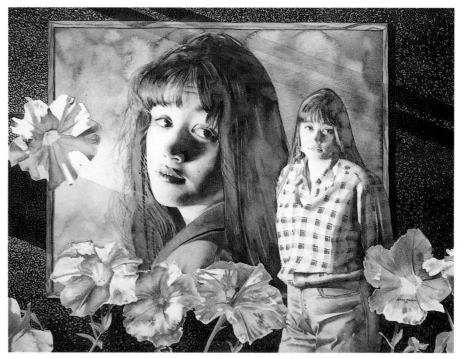

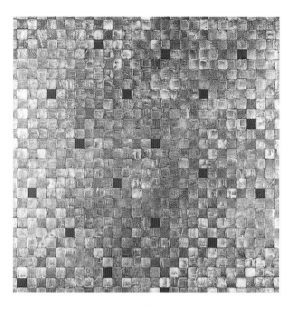

ANNELL LIVINGSTON
Urban Intersections–City Lights
30"x 30" (76 cm x 76 cm)
Arches 140 lb.
Watercolor and acrylic

EDWIN C. SHUTTLEWORTH
Road Work
21.5" x 29.5" (55 cm x 75 cm)
Arches 140 lb. cold press

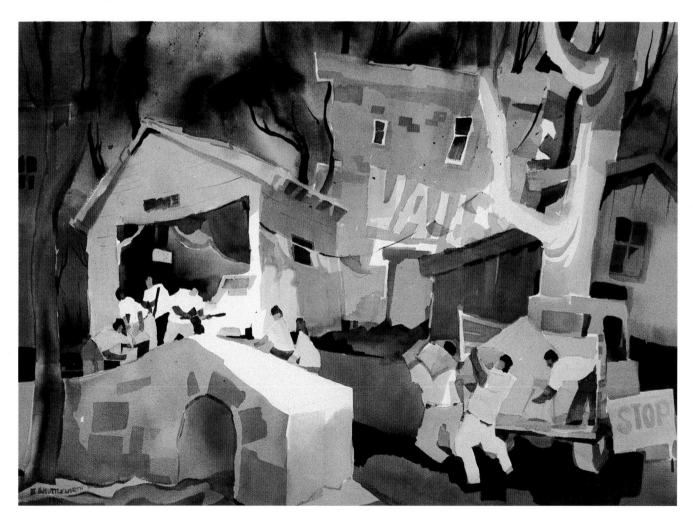

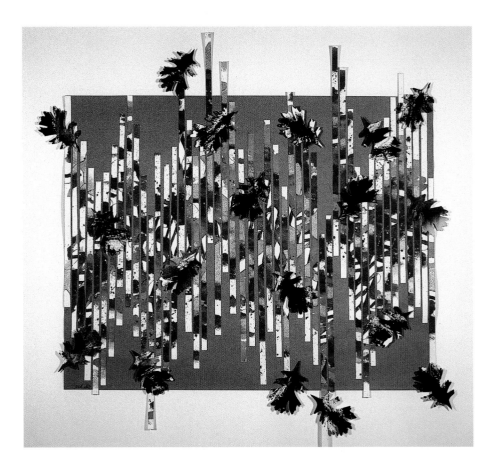

SHARON J. NAVAGE
Random Fall
29" x 28" (74 cm x 71 cm)
Arches 140 lb. rough; Canson gray
Watercolor, collage, and ink

PAUL D. BOBO
Convergence
11" x 14" (28 cm x 36 cm)
Winsor & Newton 140 lb. cold press
Watercolor and gouache

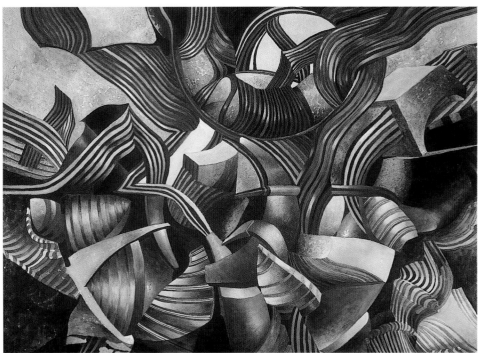

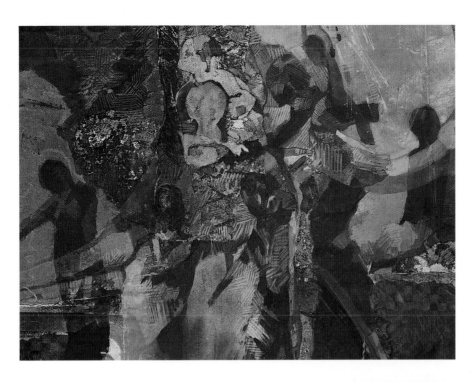

LENA R. MASSARA
Market Day
21" x 23" (74 cm x 53 cm)
Arches 140 lb. cold press
Watercolor, acrylic, stained rice papers,
collage on surface, ink, and line work

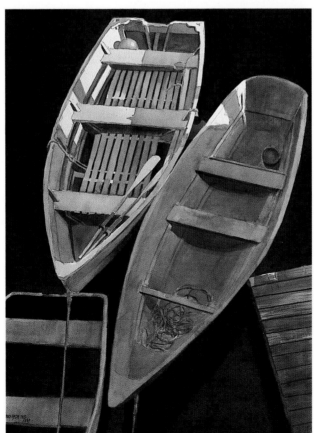

KUO YEN NG
Rockport Harbor
29" x 21" (74 cm x 53 cm)
Arches 300 lb. cold press

BILL JAMES
The Throwaway
30" x 24" (76 cm x 61 cm)
Crescent watercolor and gouache

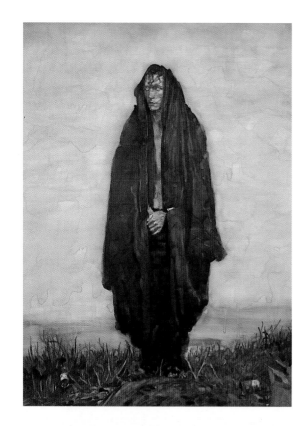

EDITH MARSHALL
Dappled Vegetation
20" x 30" (51 cm x 76 cm)
Arches 140 lb. hot press
Watercolor, ink, and watercolor pencil
Special Technique: Paint was sprayed
onto gauze, wax paper and leaf shapes
were then laid onto the wet surface.

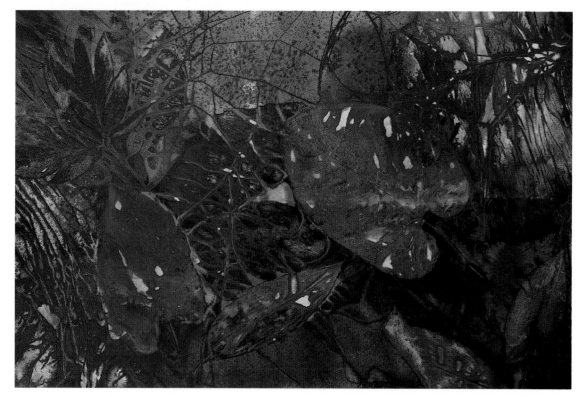

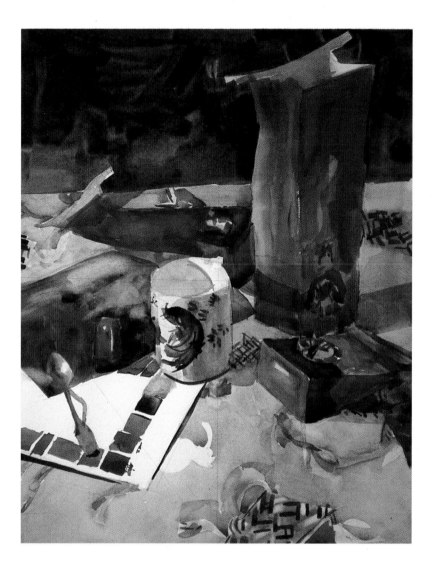

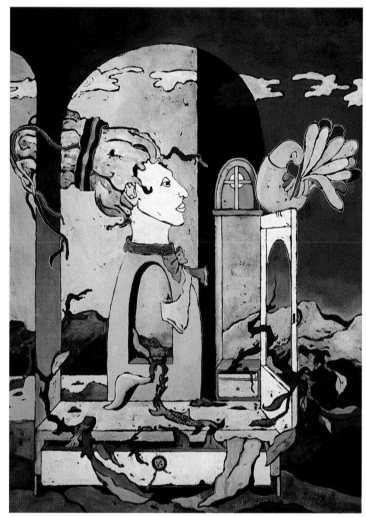

BARBARA M. PITTS
Cups and Bags
26" x 20.5" (66 cm x 52 cm)
Arches 140 lb. cold press

PHYLLIS HELLIER
D'Vinely Entwined
30" x 22" (76 cm x 56 cm)
300 lb. cold press
Watercolor, gouache, and ink

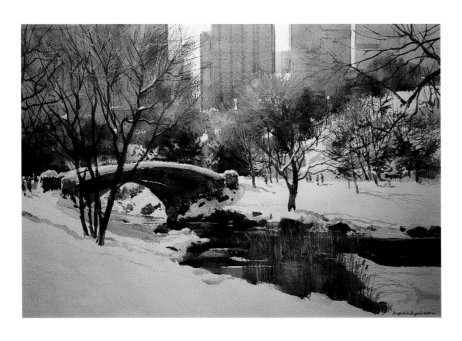

BOGOMIR BOGDANOVIC
Central Park in Winter
22" x 30" (56 cm x 76 cm)
140 lb. cold press

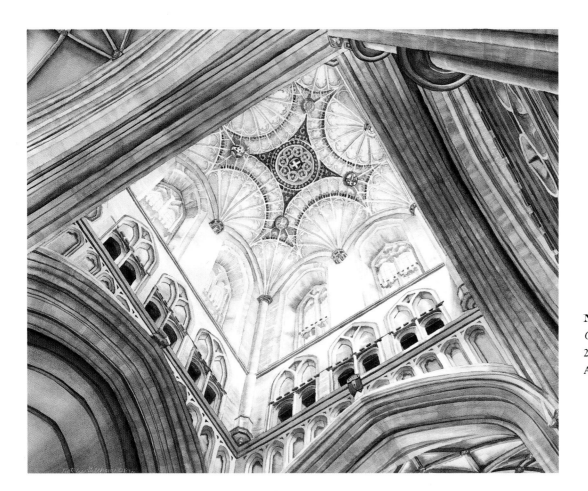

NATALIE GILLHAM
Canterbury Lantern Light
22" x 27" (56 cm x 69 cm)
Arches 140 lb. rough

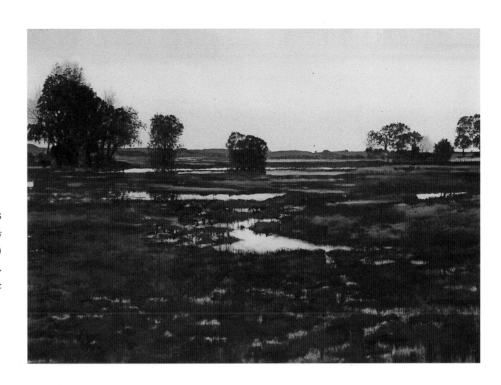

NORMAN HINES
Wetlands
36" x 52" (91 cm x 132 cm)
300 lb.
Watercolor and acrylic

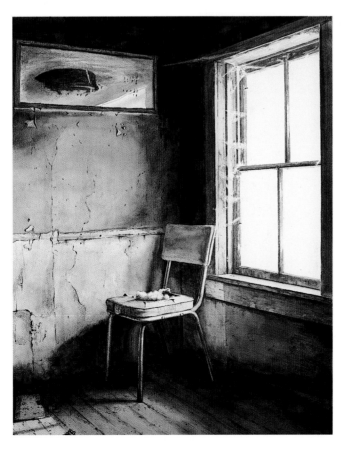

CLIFF AMRHEIN
Now We See in a Mirror Dimly
30" x 22" (76 cm x 56 cm)
Arches 300 lb. rough

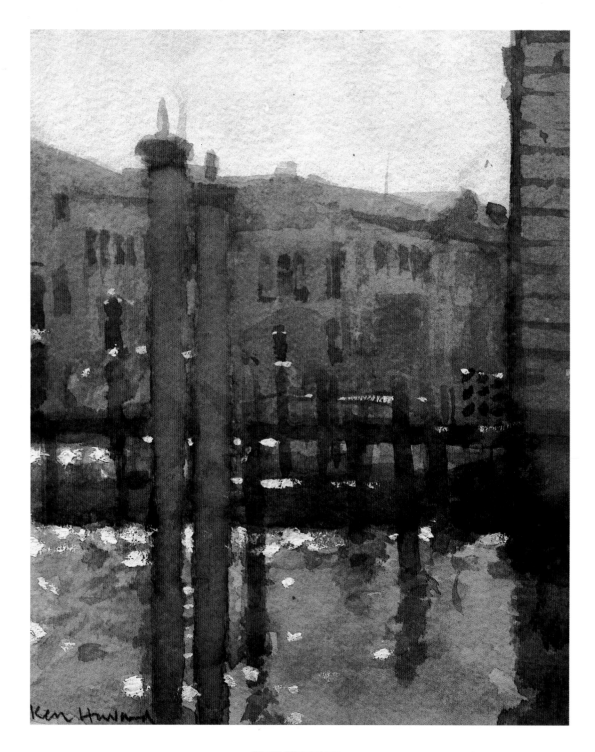

KEN HOWARD
Venice—Green and Grey
7" x 5" (18 cm x 13 cm)
Arches rough
Watercolor and Chinese white

About the
JUDGES

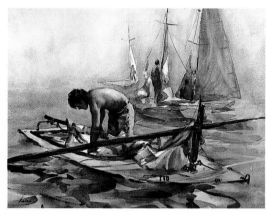

BETTY LOU SCHLEMM, A.W.S., D.F., has
been painting for more than thirty years.
Elected to the American Watercolor Society in
1964, and later elected to the Dolphin
Fellowship, she has served as both regional
vice-president and director of the American
Watercolor Society. Ms. Schlemm is also a
teacher and an author. Her painting workshops
in Rockport, Massachusetts, have become
renowned during the past twenty-nine years.
Her book *Painting with Light*, published by
Watson-Guptill in 1978, has remained a classic.
She also has recently published *Watercolor
Secrets for Painting Light*, distributed by North
Light, Cincinnati, Ohio.

After the Storm
22" x 30" (56 cm x 76 cm)
Arches 140 lb. cold press

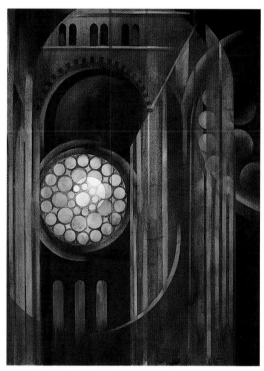

English Cathedral
30" x 22" (76 cm x 56 cm)
Arches medium

LARRY WEBSTER, N.A., A.W.S., D.F., is
a painter, printmaker, and graphic designer.
His awards include second prize in the North
American Open Watercolor Competition, the
Art Room Award of the North American
Watercolor Society, and the High Winds Medal
and the Dolphin Fellowship of the American
Watercolor Society. A graduate of
Massachusetts College of Art and Boston
University, he resides in Topsfield,
Massachusetts. His work is shown at Colby
College Art Museum, Waterville, Maine; the
DeCordova Museum, Lincoln, Massachusetts;
the Houghton Library, Harvard University,
Cambridge, Massachusetts; and the First
National Bank of Boston, among other places.

Z. L. Feng, A.W.S., N.W.S. *89*
1006 Walker Drive
Radford, VA 24141

Mary Lou Ferbert *31*
334 Parklawn Drive
Cleveland, OH 44116

Joseph Fettingis *29*
Lakeview Studio
625 Lakeview Drive
Logansport, IN 46947

Jack Flynn, A.W.S. *87*
3605 Addison Street
Virginia Beach, VA 23462

Kay Rebber Foote *108*
74 Emerald Bay
Laguna Beach, CA 92651

Christine Fortner *102*
10114 Ronald Place
Eagle River, AK 99577

Pat Fortunato *91*
70 Southwick Drive
Orchard Park, NY 14127-1650

Rowena Francis *101*
P.O. Box 1087
Rimrock, AZ 86335

Barbara Freedman *23, 64*
14622 W. Arzon Way
Sun City West, AZ 85375

Kass Morin Freeman, A.W.S. *23*
1183 Troxel Road
Lansdale, PA 19446

Jane Frey *51*
518 W. Franklin
Taylorville, IL 62568

Henry Fukuhara *85*
1214 Marine Street
Santa Monica, CA 90405

Judith Steele Gaitemand *39*
37 Rocky Neck Avenue
Gloucester, MA 01930

Dorothy Ganek *46*
125 Rynda Road
South Orange, NJ 07079

Helen Garretson, A.W.S., N.W.S. *48*
717 Maiden Choice Lane
Apt. 217
Baltimore, MD 21228

Bernard Gerstner *81*
3 Norseman Avenue
Gloucester, MA 01930

Natalie Gillham, M.W.S. *138*
289 Martin Road
Albion, MI 49224

Molly Gough *10*
3675 Buckeye Court
Boulder, CO 80304

Nessa Grainger *115*
212 Old Turnpike Road
Califon, NJ 07830

Jean Grastorf *94*
6049 4th Avenue N
St. Petersburg, FL 33710

Irwin Greenberg *23*
17 N. 67th Street
New York, NY 10023

Dorothy D. Greene *47*
6500 S.W. 128th Street
Miami, FL 33156

Beverly Grossman *70*
17960 Rancho Street
Encino, CA 91316

Susan Holefelder *72*
P.O. Box 1666
Scottsdale, AZ 85252

Robert Hallett *19*
30002 Running Deer Lane
Laguna Niguel, CA 92677

Charlotte Halliday *96*
36A Abercorn Place,
St. John's Wood
London, NW8 9XP
England

Dodie Hamilton *16*
3838 Cherry Lane
Medford, OR 97504

Ken Hansen Watercolors *78*
241 JB Drive
Polson, MT 59860

Noriko Hasegawa *5*
3105 Burkhart Lane
Sebastopol, CA 95472

Shirley Kruise Hathaway *100*
30583 J. Carls
Roseville, MI 48066

Phyllis Hellier *137*
2465 Pinellas Drive
Punta Gorda, FL 33983

Sandra Hendy *65*
82 Hunter Avenue
St. Ives 2075, Sydney
New South Wales
Australia

Sharon Hildebrand *129*
5959 St. Fillans Court W.
Dublin, OH 43017

Alan Hill *38*
2535 Tulip Lane
Langhorne, PA 19053

Norman Hines *139*
719 Flint Way
Sacramento, CA 95818

John R. Hollingsworth *109*
15426 Albright Street
Pacific Palisades, CA 90272

Ken Howard *21, 99, 140*
8 South Bolton Gardens
London, SW5 0DH
England

Sandra Humphries *18*
3503 Berkeley Place, NE
Albuquerque, NM 87106

Yumiko Ichikawa *26*
1706 Downey Street
Radford, VA 24141

Bill James, P.S.A.-M., K.A., A.W.S., N.W.S. *11, 136*
15840 S.W. 79th Court
Miami, FL 33157

Bruce G. Johnson *98*
953 E. 173rd Street
South Holland, IL 60473-3529

Edwin L. Johnson *53*
7925 N. Campbell Street
Kansas City, MO 64118-1521

Aletha A. Jones *18*
2133 Linden Avenue
Madison, WI 53704

Jane E. Jones *50*
5914 Bent Trail
Dallas, TX 75248

Jean Kalin, A.P.S.C., K.W.S. *119*
11630 NW 64th Street
Kansas City, MO 64152

M. C. Kanouse *28*
6346 Tahoe Lane, SE
Grand Rapids, MI 49546

Dell Keathley *73*
124 Waterford Place
Alexandria, Virginia 22314

Barbara Keyser *102*
304 Tower Drive
San Antonio, TX 78232

Everett Raymond Kinstler, N.A., A.W.S. *6*
15 Gramercy Park
New York, NY 10003

Judith Klausenstock *14, 30*
94 Reed Ranch Road
Tiburon, CA 94920

Lynne Kroll *116*
3971 N.W. 101 Drive
Coral Springs, FL 33065

Chris Krupinski *17*
10602 Barn Swallow Court
Fairfax, VA 22032

Sandra Thruber Kunz *83*
249 Daffodil Drive
Freehold, NJ 07728

Margaret Laurie *72*
4 Blake Court
Gloucester, MA
01930-3204

Alexis Lavine *36*
8 Greene Street
Cumberland, MD 21502

Nat Lewis *22, 27*
51 Overlook Road
Caldwell, NJ 07006

Jerry Little *26*
2549 Pine Knoll Drive #4
Walnut Creek, CA 94595

Katherine Chang Liu *14*
1338 Heritage Place
Westlake Village, CA 91362

Annell Livingston *133*
4032 NDCBU
Taos, NM 87571

Sherry Loehr *12, 91*
1365 Shippee Lane
Ojai, CA 93023

Connie Lucas *40*
1933 Bellingham
Canton, MI 48188-1808

Rosemary MacBird, N.W.S. *125*
913 Q Ronda Sevilla
Laguna Hills, CA 92653

James Malady *25*
HC89 Box 223
Pocono Summit, PA 18346

Joseph Manning *36*
5745 Pine Terrace
Plantation, FL 33317

Martha Mans *57*
5755 Timpa Road
Chipita Park, CO 80809

Edith Marshall *136*
Rte. 1, Box 57-B
Hancock, MI 49930

Daniel J. Marsula, A.W.S. *123*
2828 Castleview Drive
Pittsburgh, PA 15227

Lena R. Massara *135*
3 Lee Ward Court
Salem, SC 29676

Benjamin Mau, N.W.S. *47*
One Lateer Drive
Normal, IL 61761

Diane Maxey *7*
7540 N. Lakeside Lane
Paradise Valley, AZ 85253

John McIver, A.W.S., N.W.S., W.H.S. *58*
1208 Greenway Drive
High Point, NC 27262

Joan McKasson *84*
7976 Lake Cayuga Drive
San Diego, CA 92119

Geraldine McKeown, N.W.S. *42*
227 Gallaher Road
Elkton, MD 21921

Suzanne McWhinnie *8*
32 Paper Mill Drive
Madison, CT 06443

Morris Meyer, N.W.S. *59*
8636 Gavinton Court
Dublin, OH 43017

Anita Meynig *86, 126*
6335 Brookshire Drive
Dallas, TX 75230-4017

Edward Minchin, A.W.S. *24*
54 Emerson Street
Rockland, MA 02370

Robert Eric Moore, N.A.,
A.W.S. *132*
111 Cider Hill Road
York, ME 03909-5213

Scott Moore *5, 52*
1435 Regatta Road
Laguna Beach, CA 92651

Sharon J. Navage *134*
2906 Laurel Avenue
Odessa, TX 79762

Georgia A. Newton *35, 42*
1032 Birch Creek Drive
Wilmington, NC 28403

JoRene Newton *41*
50 Palmer Lane, Woodcreek
Wimberley, TX 78676

Kuo Yen Ng *135*
4514 Hollyridge Drive
San Antonio, TX 78228-1819

Tom Nicholas, N.A., A.W.S.
79
7 Wildon Heights
Rockport, MA 01966

Michael L. Nicholson *15, 54*
255 South Brookside Drive
Wichita, KS 67218

Paul W. Niemiec, Jr. *32, 68*
P.O. Box 674
Baldwinsville, NY 13027

Vernon Nye *69*
305 Chablis S.
Calistoga, CA 94515

Terry O'Maley *111*
131 Richards Road
Benton, ME 04901

Rudolph Ohrning *25*
3318 Wilder Street
Skokie, IL 60076

Robert S. Oliver *60*
4111 E. San Miguel
Phoenix, AZ 85018

Jane Oliver *84*
20 Park Avenue
Maplewood, NJ 07040

Belle Osipow *114*
3465 Wonderview Drive
Los Angeles, CA 90068

Donald W. Patterson *106*
441 Cardinal Court N.
New Hope, PA 18938

Dick Phillips *51, 68*
7829 E. Hubbell
Scottsdale, AZ 85257

Jim Pittman *88*
Box 430
Wakefield, VA 23888

Barbara M. Pitts *137*
355 East Marion Street
Seattle, WA 98122-5258

John Pollock *38, 66*
1009 Nutter Boulevard
Billings, MT 59105

Barbara Sorenson Rambadt
62
3440 Nagawicka Road
Hartland, WI 53029

Judithe Randall *62, 82*
2170 Hollyridge Drive
Los Angeles, CA 90068

L. Herb Rather, Jr. *17, 98*
Rt. 1 Box 89
Lampasas, TX 76550

Pat Regan *125*
120 W. Brainard
Pensacola, FL 32501-2625

Donald G. Renner *97*
540 Holly Lane
Plantation, FL 33317

Robert Sakson *32*
10 Stacey Avenue
Trenton, NJ 08618-3421

John T. Salminen *46*
6021 Arnold Road
Duluth, MN 55803

Betty Carmell Savenor *45*
4305 Highland Oaks Circle
Sarasota, FL 34235

Janice Ulm Sayles *10*
4773 Tapestry Drive
Fairfax, VA 22032

Nick Scalise *96*
59 Susan Lane
Meriden, CT 06450

Betty Lou Schlemm, A.W.S.,
D.F. *141*
11 Caleb's Lane
Rockport, MA 01966

Aïda Schneider *20*
31084 E. Sunset Drive N.
Redlands, CA 92373

Ken Schulz, A.W.S. *59*
P.O. Box 396
Gatlinburg, TN 37738

Susan Amstater Schwartz
101
509 Linda
El Paso, TX 79922

Barbara Scullin *92*
128 Paulison Avenue
Ridgefield Park, NJ 07760

George Shedd, A.W.S.,
A.A.A., N.E.W.S. *55*
46 Paulson Drive
Burlington, MA 01803

Morris Shubin *124*
313 N. 12th Street
Montebello, CA 90640

Edwin C. Shuttleworth,
F.W.S. *133*
3216 Chapel Hill Boulevard
Boynton Beach, FL 33435

Delda Skinner *112*
8111 Doe Meadow
Austin, TX 78749

Susan Spencer *100*
306 Gordon Parkway
Syracuse, NY 13219

Donald Stoltenberg *43*
947 Satucket Road
Brewster, MA 02631

Gregory Strachov *12*
797 Mentor Avenue
Painesville, OH 44077

Paul Strisik, N.A., A.W.S.
110
123 Marmion Way
Rockport, MA 01966

Richard Sulea *130*
660 E. 8th Street
Salem, OH 44460

Anne D. Sullivan *77*
28 Rindo Park Drive
Lowell, MA 01851

Heidi Taillefer *67*
470 6th Avenue
Verdun, Quebec H4G 3A1
Canada

Janis Theodore *9*
274 Beacon Street
Boston, MA 02116

Greg Tisdale *50*
35 Briarwood Place
Grosse Pointe Farms, MI
48236

Linda Tompkin, A.W.S.,
N.W.S. *83, 105*
4780 Medina Road
Copley, OH 44321-1141

James Toogood, A.W.S.
33, 107
920 Park Drive
Cherry Hill, NJ 08002

Thomas V. Trausch *127*
2403 Mustang Trail
Woodstock, IL 60098

Harold Walkup *65*
5605 S.W. Rockwood Court
Beaverton, OR 97007

Wolodimira Vera Wasiczko
79
5 Young's Drive
Flemington, NJ 08822

Dorothy Watkeys-Barberis
128
217 Lincoln Avenue
Elmwood Park, NJ 07407-
2822

Larry Webster, N.A., A.W.S.,
D.F. *141*
116 Perkins Row
Topsfield, MA 01983

Alice W. Weidenbusch *35*
1480 Oakmont Place
Niceville, FL 32578

Sharon Weilbaecher *93*
31 Plover Street
New Orleans, LA 70124

Murray Wentworth *122*
132 Central Street
Norwell, MA 02061

E. Gordon West, A.W.S.,
N.W.S. *129*
2638 Waterford
San Antonio, TX 78217

Michael Whittlesea *41*
Richmond Cottage High Street
Hurley, Berkshire SL6 5LT
England

Mary Wilbanks, N.W.S. *49*
18307 Champion Forest Drive
Spring, TX 77379

Joyce Williams *86*
P.O. Box 192
Tenants Harbor, ME 04860

Douglas Wiltraut *13, 53*
969 Catasauqua Road
Whitehall, PA 18052

Ruth Wynn, A.W.S. *118*
30 Oakledge Road
Waltham, MA 02154

Ann Zeilinski *119*
Ford Cove
Hornby Island, BC V0R 1Z0
Canada

Elena Zolotnitsky *80*
205 Duke of York Lane, T-2
Cockeysville, MD 21030